IMAGES
of America

STEELTON

On the cover: This picture shows the trackwork assembly at the frog and switch department of the Steelton plant. The frog refers to the crossing point of two rails. A frog forms part of a railroad switch, enabling trains to be guided from one track to another. *Frog* in track lingo comes from the resemblance of the triangular assemblage of rails to the frog of a horse's hoof. The Steelton plant was a major producer of steel rails in the United States. (Courtesy Center for Pennsylvania Culture Studies, Pennsylvania State University Harrisburg.)

IMAGES
of America

STEELTON

Michael Barton and Simon J. Bronner

ARCADIA
PUBLISHING

Published by Arcadia Publishing
Charleston SC, Chicago IL, Portsmouth NH, San Francisco CA

Printed in the United States of America

Library of Congress Catalog Card Number: 2007937776

For all general information contact Arcadia Publishing at:
Telephone 843-853-2070
Fax 843-853-0044
E-mail sales@arcadiapublishing.com
For customer service and orders:
Toll-Free 1-888-313-2665

Visit us on the Internet at www.arcadiapublishing.com

To all the peoples of Steelton, past and present, with appreciation.

CONTENTS

ACKNOWLEDGMENTS

First, of course, we must acknowledge the contribution that John B. Yetter made to this volume. If he had not bequeathed his collection of more than 2,000 Steelton photographs to Pennsylvania State University Harrisburg, we would not have been able put together this kind of book. The difference between amateur and professional historians is debatable, suffice it to say that Yetter was a very productive investigator of the past, and students of Steelton's history will always be indebted to him.

The Yetter Photograph Collection is maintained at the Center for Pennsylvania Culture Studies at Pennsylvania State University Harrisburg's library. We are grateful that Dr. Greg Crawford, library director, has supported both the collection and the center. Our graduate student assistants working at the center—Cali Pitchel, Melanie Steimle, Sarah Hopkins, and Reiko Gibson—helped a good deal with this book. They spent many hours scanning the Steelton photographs so that we could more easily organize and edit them on our computers. Other American Studies graduate and undergraduate students did research on Steelton, and their results contributed to this project, both directly and indirectly. They are William Starsinic, Lorna LeMelle, Stephen Chortanoff, John Fortino, Tom Boyle, and Barbara Doyle. Our friend Susan Silver Cohen was most generous in letting us borrow photographs of members of Steelton's Jewish community; these were a vital addition to the book. Our staff in the American Studies program and the School of Humanities at Pennsylvania State University Harrisburg—Cindy Leach and Sue Etter—provided us, as usual, with their valuable stock in trade: administrative assistance on this project. Because she is a Steelton native, we especially hope that Cindy enjoys the book. Our editor at Arcadia, Erin Vosgien, was professional throughout the book-making process; fortunately for us, she was flexible and forgiving at the right times too.

Finally, we are grateful to Steelton—for being Steelton, a most interesting subject for a book, and a most helpful community to this country.

—Michael Barton and Simon J. Bronner

INTRODUCTION

In the 1860s, the Pennsylvania Railroad needed a plant to build steel rails that would replace its weaker wrought iron rails. It found what looked to be an ideal location just east of Harrisburg that was close to its main rail line as well as the Pennsylvania Canal and the Cornwall ore banks. There, in 1866, on flat land alongside the Susquehanna River, it organized a subsidiary, the Pennsylvania Steel Company, and laid out a town on the higher ground that sloped steeply down to the river. They named the town Baldwin, in honor of the Baldwin Locomotive works in Philadelphia. In 1871, when a post office was established a new name was needed because another town in Pennsylvania had already claimed Baldwin. The town, now identified with the steel mill, changed its name to Steel Works, and by 1880 the name had changed again when Steelton was incorporated as a borough. Here was the first factory in America devoted to the production of the ultimate construction material—hard steel. The company began by using the Bessemer converter process first developed in England. Soon its rolling mills were making rails, blast furnaces were producing pig iron, the frog and switch department was constructing track switches, and the merchant mill was creating bars, billets, and slabs.

The first steelworkers and their managers came from rural Pennsylvania, Ireland, England, and Germany. By the 1880s and 1890s, African Americans were moving in from the South while Slavs and Italians were migrating from southern Europe. By the beginning of the 20th century, the borough had 12,000 residents. The majority of the workforce was still American-born, but Steelton was on its way to becoming a distinctively ethnic community.

The Dillingham Report, commissioned by Congress to study the effects of immigration, described the facts of life in Steelton in 1910. By that time, one third of the residents were foreign-born. There were about 2,000 Serbians, 2,000 Croatians, 1,200 blacks, and 1,000 Germans among the borough's 14,000-plus residents. Other national groups with populations under 1,000—33 peoples in all—included Macedonian-Bulgarians, Slovenes, Italians, Irish, East European Jews, Slovaks, Poles, and Romanians. On the west side flatlands lived Bulgarians and some Croats and Serbs; at the eastern "lower end" were Italians and Slovenes and the bulk of the Croats and Serbs. Blacks were in the center of town near Front Street; native-born whites, Irish, and Germans were mixed together on the highlands to the west.

The borough was an ethnic checkerboard, not a melting pot, writes John Bodnar, who in the 1970s used Steelton as a scholarly case study of the link between industrialization and immigration in the early 20th century. Jobs in the plant were patterned by race and ethnicity, a system that was then supported by kin connections and tradition. Croats and Slovenes worked

the open-hearth furnaces, Serbs and blacks, the blast furnaces. The unskilled general labor department was nearly all Slavic; the skilled workers in the frog and switch department were virtually all Americans, Germans, English, or Irish. Likewise, nearly all the supervisors of the various departments had northern European heritage. One could explain these patterns of employment as a function of prejudice and discrimination, especially when race was concerned, but it could also be argued that those who had come first to Steelton had been served first, and those who came later were last in line. In any case, the later immigrants magnified their heritage, turned inward, and established ethnic societies in their own defense. But they would also count their blessings and fly the stars and stripes.

As the business prospered, workers wanted more than the company provided. The Amalgamated Association of Steel and Iron Workers had presented their demands for higher wages and recognition of their union in 1891. Officials closed all the bars, workers marched through town, and the company brought in hundreds of black strikebreakers from the South. The labor action failed, and unionism was defunct for the next 25 years. In 1904, disgusted with piecework wages, some Slavs boarded ship and went back to Europe. Other strikes were broken in 1906 and 1912. Bethlehem Steel Corporation purchased Pennsylvania Steel in 1916 and began to make investments in the mill, including new blast furnaces and electric and steam plants. That did not prevent the steel strike of 1919, led by the American Federation of Labor (AFL) and old-stock whites. Strike leaders complained that "modern industrial autocrats" were worse than King George III. However, Slavic, Italian, and black workers were not embraced by the AFL and the strike failed.

Steeltonians met adversity head on during the Depression and World War II. The Veterans of Foreign Wars Post 710 has a large placard facing the street that lists nearly 2,000 names on Steelton's honor roll of World War II veterans. Steelton, it turns out, provided almost one sixth of its population to the armed forces, or in other words, most of the men who were eligible to serve. About 50 of the names are in gold, meaning the soldiers were lost in the war.

The last half of the 20th century was not pretty in Steelton. Company policy, writes Bodnar, kept Slavs, Italians, and blacks apart and the English, German, and Irish on top, both in the plant and the borough. Fierce competition from overseas cut the fat and the muscle out of American steelmaking. Steeltonians who had assimilated and prospered moved out of the borough, to the east shore suburbs or to Harrisburg. The great flood of 1972 was a turning point for many residents. It ravaged the old west side and suddenly it was gone, a victim of bulldozers sent in by the government. The steel mill on the east side, once a great industrial landscape, was nearly leveled by the end of the century.

With the economic downturn, Steelton's population declined—it was 5,609 in 2000, compared to 14,246 in 1910. Employment in the mill was over 9,000 at its peak; in 2006, it was barely 600. Median income dropped to $36,684, as against Pennsylvania's $45,125. Nearly half the students became eligible for reduced cost or free lunches, and less than 10 percent of residents had a bachelor's degree or higher. During the steel mill's boom times in the early 20th century, most residents worked in town, but as the 21st century dawned, only 12.5 percent of its residents made their living in Steelton. Still, one consistent feature has been its working-class composition, with a plurality employed presently in construction, health care, and "working for the state."

A drive down Front Street reveals other changes. One still sees signs for the Croatian St. Lawrence Club Fraternal Union Lodge No. 13, the Slovenian St. Aloysius Society No. 42, and the Loyal Order of the Moose Lodge 382. But the Moose lodge is across the street from the Tres Hermanos Taqueria Mexican Restaurant and Store; near St. Lawrence is the Al-Madina Hawerma Place serving kabobs with a sign in Arabic; and St. Aloysius is close to a café featuring Puerto Rican fare. The Belgrade Bakery that used to make "Hunky" bread is now the Caribbean Bakery that sells Bistec, Tripleta, and Cubano sandwiches. In the middle of town, opposite the main gate of the mill, were once the local offices of Bethlehem Steel. Today on the building stands the sign for Mittal, a conglomerate headquartered in Rotterdam, Netherlands, that is the largest steel producer in the world, with 320,000 employees in 60 countries. Actually,

the official corporate name is now Arcelor Mittal, following the merger in 2006 of Arcelor and Mittal, then the world's two largest steel companies. The corporate behemoth keeps the steel plant going and gives credibility to the civic leaders' claims posted on Front Street: "The New Steelton: The Urban Renaissance Continues" and "Steelton on the Move," both promising redevelopment.

The community's latest triumph can symbolize hope for the future. On December 14, 2007, Steel-High won the Class A Football championship of the Pennsylvania Interscholastic Athletic Association by a convincing score of 34-15. (For the record, the school's official name is Steelton Highspire High School, dating from 1957, when Steelton and neighboring Highspire were united for educational efficiency.) In covering the game, the *Harrisburg Patriot-News* commented that, "the game comes at a particularly poignant time for Steelton" because, "struggling to recover from massive layoffs at the steel mill over the last few decades, Steelton is trying to reinvent itself, buying up properties along Route 230, called Front Street as it runs through town, to build office buildings and shops to make over its business district." Joining the legends of the Reich brothers, Miles Fox, and Warren Heller is now junior sensation Jeremiah Young, who ran 45 times for a record 292 yards and four touchdowns in the state final.

The win was Steel-High's 662nd victory in 1,101 games, and its first official state title won on the playing field, since its top rankings going back a century had all been bestowed by sports reporters. The last time Steel-High had been ranked first at the end of the season was in 1978. When Steelton football started in 1894, they were playing anybody who would take the field against them, including college and club teams, and they earned wider renown with wins reported in the press as David-like triumphs over Goliath foes. They boasted their working-class toughness in Steelton High School's original moniker of the "Ironmen." When their big-school competitors inevitably out-sized and out-gunned them later in the century, Steel-High made the decision in 1997 to withdraw from Class AAAA football (over 541 males in school) and join Class A (fewer than 198 males). In basketball, however, Steelton still plays over its head, competing in Class AAA. Remarkably, in 1992, they were AAAA state champions, and in 1998, they took the AAA state championship and then repeated as AAA champs in 2000 and 2005.

Simply stated, no other school in Pennsylvania has dared so much in major sports and done so well.

The treasure trove of photographs that enrich this book comes largely from the collection amassed by John Yetter, born and bred in Steelton (1914–1994). In the absence of a historical society for Steelton, he took upon himself the task of compiling in his senior years a visual historical record of the town he loved. Before the days of eBay allowed online searching, Yetter solicited photographs from family and friends, he scoured flea markets, and he snapped what he could of pivotal moments in Steelton life. He rescued more than one store of valuable material from the dumpster and sought the subjects that captivated residents: sports, parades, floods, shops, schools, and especially the central icon of the steelworks. With magnifying glass in hand, he set about to identify the participants and their scenes. He carefully numbered each photograph and catalogued them in his own filing system. He called upon his organizational skills as a production supervisor at the steel plant and his journalistic experience with *Steel Points*, the high school newspaper. His work culminated in his self-published reminiscence of the town titled *Steelton, Pennsylvania: Stop–Look–Listen . . .* (1979). It certainly was different in tone and content from the more critical scholarly volume by Bodnar published two years earlier. Whereas Yetter's work peeked into the past with anecdotes and photographs that identified the characters and buildings that Steeltonians celebrated, Bodnar offered Steelton as a lesson in the pivotal role that ethnic labor played in American mass industrialization in the decades before World War II. On one thing they certainly agreed—the steel plant was central to the development, and persona, of the town.

Our contribution is to read the photographs that Yetter donated to the Center for Pennsylvania Culture Studies at Pennsylvania State University Harrisburg in light of Bodnar's analysis and

take that interpretation through the rest of the century. In representative photographs of the postwar Kolo Club Marian set against the memories of the prewar Balkan Sextette, we view the community efforts at ethnic continuity. We highlight the proud edifice of St. James and its transformation as new immigrants arrive from Muslim countries into the Islamic Society of Greater Harrisburg. We also record the historical process visually, by examining the consumer revolution from market to grocery to superstore. We must note school spirit captured on film, as the high school was a major unifying institution for the town. At the same time, we recognize churches for maintaining ethnic traditions. Unlike Yetter, we are not so preoccupied with telling you the names of the pictured individuals as much as setting them in the distinctive historical and cultural sweep of the national and regional experience.

Toward that end, we have an interpretive perspective to offer through the selection and captioning of photographs. To answer the question of how the town persisted even after the decline of the mill and the destruction of a major portion of the town, we see a cultural focus that remains through time and distinguishes Steelton from the surrounding communities of Harrisburg, Middletown, Hershey, and Hummelstown. Among those places, Steelton in the regional imagination was the place where ethnicity was public and labor was central. Photographs tended to show workers with tools of their trades rather than diplomas in hand; affiliation with ethnic lodges, organizations, and churches was expected. People still look forward to performances of Kolo Club Marian and ethnic church picnics in Serb Park, even if they are not of Balkan heritage. New immigrants change the ethnic complexion of the cultural landscape, but they sustain the town's pluralistic image. Sports fit into the ethnic-industrial image because of the persona of working-class toughness and grit that they project. Spectators could appreciate the way that Steeltonians battled gloriously, not only on the playing field but also against nature, as the town's record of bouncing back from disastrous floods will attest.

The steel plant, if not producing in the quantity it did, is still a landmark that people live by and a symbol with which they identify. Arrival on Front Street by the mill is still a starting point for social interchange and a sign of cohesion as a town. We show visually the way that the built environment affected the way people thought about their sense of place, and we emphasize the cultural events that brought people together within the landscape, including parades, holidays, and religious events. Finally, we show another symbolic center, the high school, overlooking the town, plant, and river, and note its community-wide functions.

In sum, as the signs on Front Street, Cottage Hill, and the taverns downtown declare, you are in Roller Country, a different kind of place.

One

STEEL

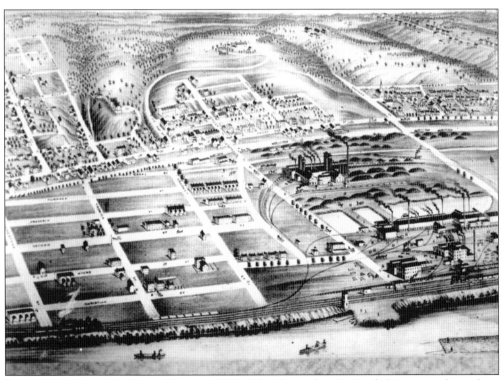

BIRD'S-EYE VIEW OF STEEL WORKS, 1878. The Pennsylvania Steel Company plant along the Susquehanna River had added a blooming mill in 1876, including a 12-ton steam hammer, considered the largest in the country at the time. The growth of the settlement around the plant earned it attention in one of the thousands of panoramic pictorial maps drawn at an oblique angle and labeled "Bird's Eye View." The name Steel Works for the town had been adopted in 1871 to replace the village of Baldwin because a post office already existed in Allegheny County with that name. Because the town name became confused with the plant, another change to the post office occurred in 1879 when the name of Steelton was adopted.

PENNSYLVANIA STEEL COMPANY.

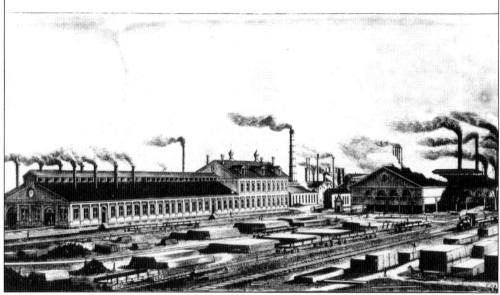

PICTURING THE MILL. An early engraving gives dignity to the buildings of the Pennsylvania Steel Company. Bessemer converters and open-hearth furnaces were operating in the plant, and steel rails were in production.

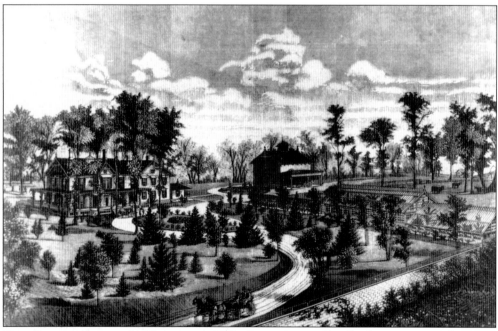

THE SUPERINTENDENT'S HOME, C. 1870. Pennsylvania Steel's first superintendent was Alexander L. Holley, and his home was known as Holley's Mansion. The last occupant was Frank Robbins, general manager of Bethlehem Steel's Steelton Plant. The house, adjoining stable and barn, and greenhouses were torn down shortly after World War II.

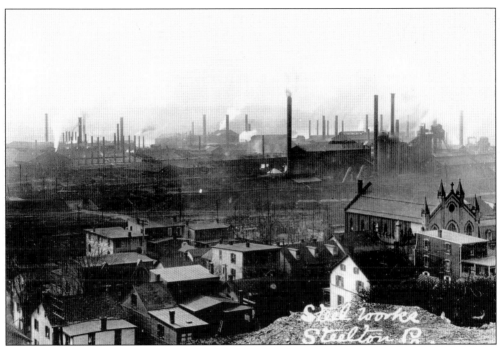

THE BETHLEHEM STEEL MILLS, 1931. Photographed from the high ground of Cottage Hill, a postcard shows the overwhelming presence of the Bethlehem Steel mills and offices. In 1931, about 5,000 men were employed in the mills, and just over 13,000 persons lived in the borough.

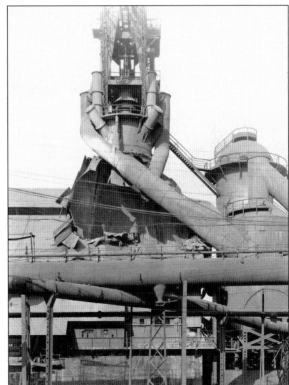

BLASTED FURNACE. A great blast blew a hole through the roof of a furnace in the early 1920s. Indeed, working in the mills was a hazardous operation. In 1902, five men—Jurovic, Marovoich, Gatis, Muza, and Radjanovic—were burned to death when molten metal from an open hearth poured on them. In 1907, 19 men were killed.

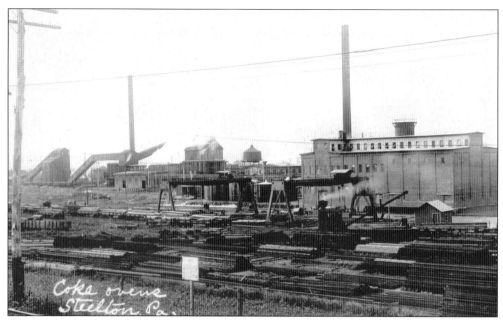

COKE OVENS. The multistory coke ovens of the Pennsylvania Steel Company stand out against the mountain ridge on the west shore of the Susquehanna River, and they tower over the tracks at the Steelton plant. Perhaps the sheer size of the facilities required for steelmaking speaks to the ambition and grit of the men who were attracted to the industry, whether they were managers or workers.

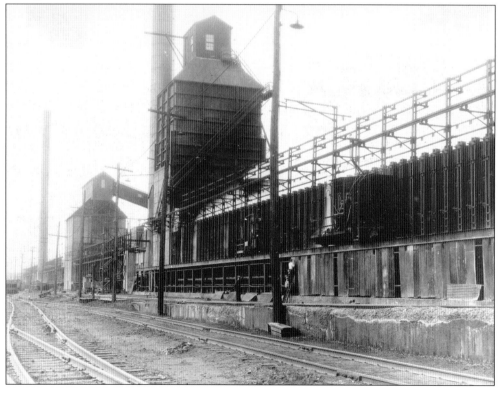

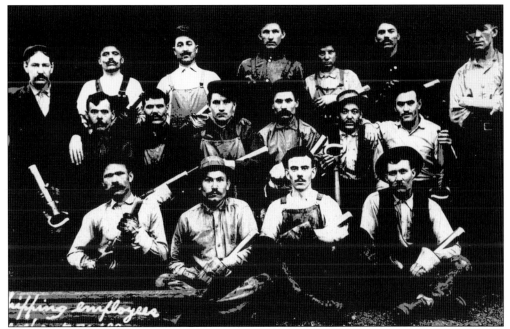

CHIPPING EMPLOYEES, 1909. Among the skilled groups at the steel plant were the chipping employees shown here holding the tools of their trade in 1909. Chipping is a method for removing seams and other surface defects from sheet metal with chisels or gouges so that such defects will not be worked into the finished product.

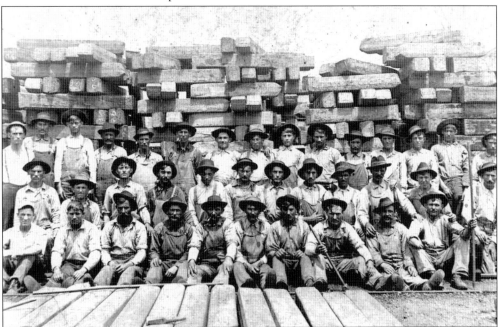

MEN AT WORK, 1909. A crew of 37 steelworkers poses at Pennsylvania Steel's Merchant Mill in 1909. They look as solid and sturdy as the wooden ties that surround them. An unskilled worker earned about 12¢ an hour in the mill in 1908, about average wages for the eastern United States and better earnings than agricultural work.

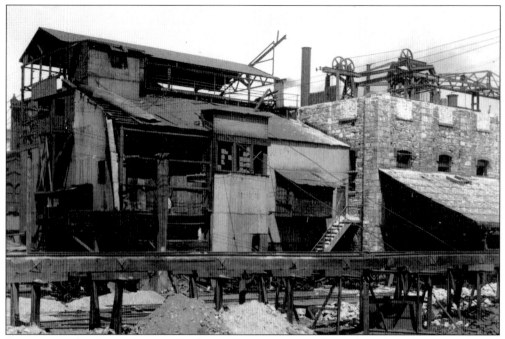

REMAINS OF THE BESSEMER, 1911. The Bessemer converter, shown here from the river side, was once the "pride of the industry," notes John Yetter. Built in 1880, it was replaced by open-hearth steelmaking, which was in turn replaced by electric furnaces.

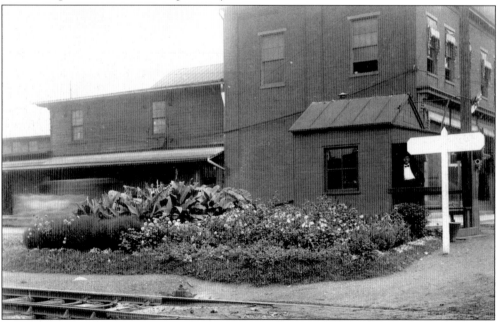

THE COMPANY STORE, 1911. In the background, Bent's Store, later known as the Steelton Store Company, was built in the 1870s. As business grew, more buildings were added. Workers shopped here, and the cost of goods they purchased was deducted from their payroll checks. The small building in front, with the bow-tied watchman standing in the doorway, is the Locust Street Watchbox.

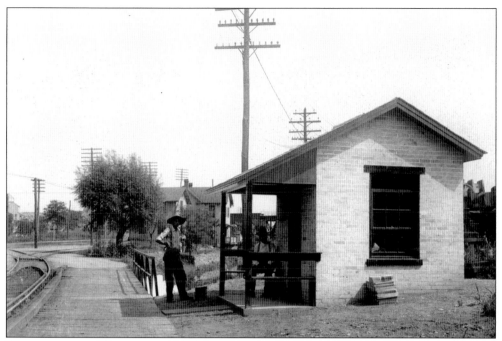

WAITING AT THE WATCHBOX, 1911. Trains carrying materials pass by the security watchbox on the west side of the canal in 1911. It was the Pennsylvania Railroad that started Pennsylvania Steel as a subsidiary company because the railroad needed rails made of harder steel.

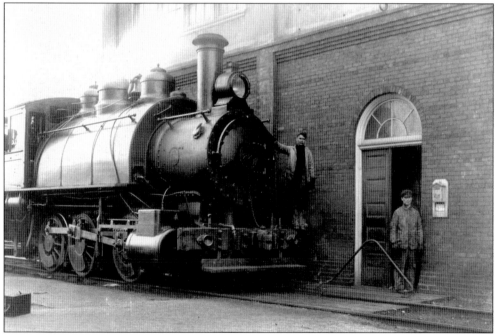

LOCOMOTIVE AT THE COMPANY ROUNDHOUSE, C. 1911. John Yetter's notes call this picture a "Pennsylvania Steel Memory." Indeed, the sight and sound of steam locomotives must have been memorable to central Pennsylvanians in the past. About the time this picture was taken, 1911, more than 100 trains a day were running through nearby Harrisburg.

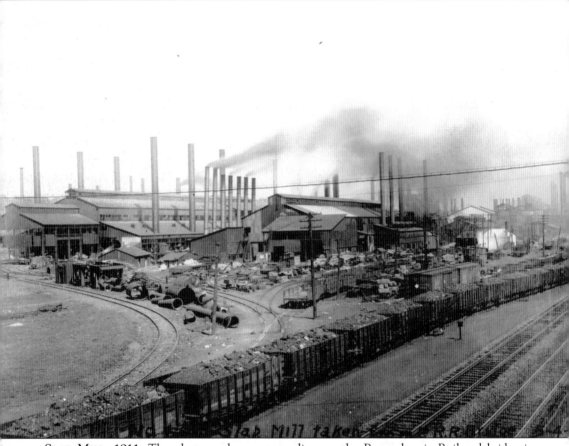

SLAB MILL, 1911. The photographer was standing on the Pennsylvania Railroad bridge in Steelton when he took this photograph of Pennsylvania Steel's open-hearth slab mill. Like the steel industry, the "Pennsy" trains were another giant of the industrial age.

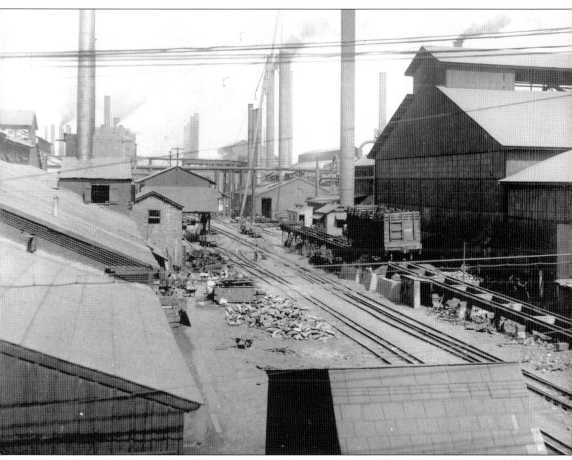

OPEN-HEARTH AREA, 1911. From the vantage point of a rooftop, the lower end of the open-hearth mill at Pennsylvania Steel is seen in 1911. Most of the smokestacks are gone today, and many of the buildings too.

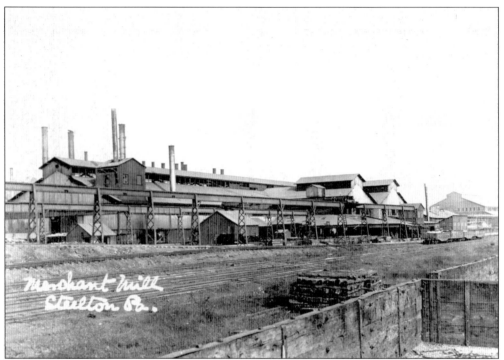

THE MERCHANT MILL, 1909. The Merchant Mill at Pennsylvania Steel and the other mills stretched the entire length of Steelton, from Highspire to Harrisburg, about four miles.

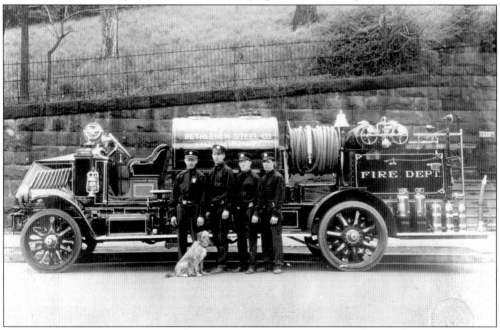

THE COMPANY FIRE TRUCK. Bethlehem Steel Company's Mack fire truck was a chemical truck with a soda and acid tank for chemical conflagrations at the plant. Note the solid rubber tires. Fire was the greatest threat to city and property throughout American history. In nearby Harrisburg, it destroyed the state capitol in 1897 and the opera house in 1904.

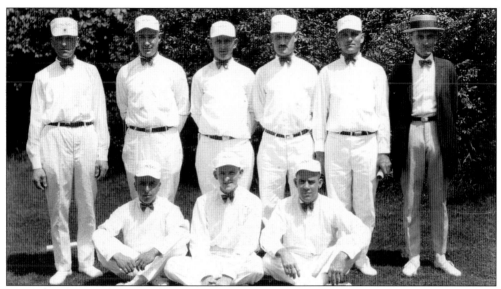

STEEL FOUNDRY FIRST AID TEAM. First aid teams at the plant assisted company physician Dr. Andrew Griest. The steel foundry first aid team, pictured here in 1925, is spotlessly costumed for the general first aid meet held at Harrisburg's City Island Park. This steel foundry team had won the first aid contest among teams at the Steelton plant—one of the "big events" of the year, according to Yetter—and competed against teams from other Bethlehem Steel plants at the general meet, where they placed fourth. Seated in the center is Bernard Yetter, who played the patient. The steel foundry team pictured with the trophy won first prize in the general meet in 1930. Standing second from the left is Charles Galley, team captain; standing on the far right is foundry superintendent Bill Cooper.

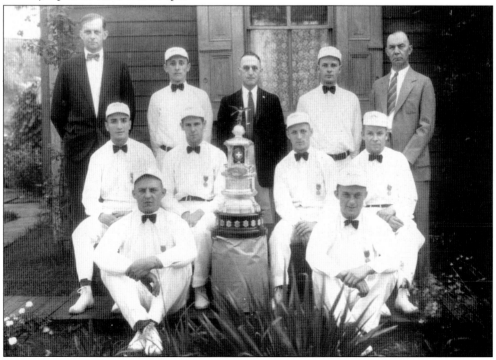

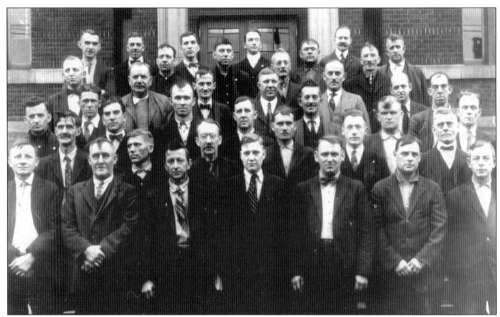

EMPLOYEES' REPRESENTATIVES, 1921. Before the establishment of the Congress of Industrial Organizations (CIO) union in the 1940s, employees' representatives spoke for steelworkers at the plant. Pictured here in 1921, they came from the frog and switch, the blast furnace, the steel foundry, the open hearth, the rail mill, the coke oven, the machine shop, and other departments. Most of them were of English, German, or Irish stock rather than Slavic, Italian, or African American.

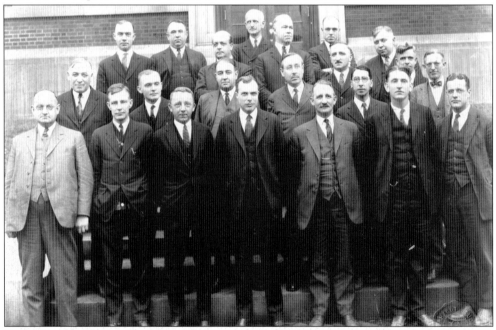

DEPARTMENT SUPERINTENDENTS, 1911. Bethlehem Steel's 22 departmental superintendents stand proudly in front of company headquarters in Steelton. Like the employees' representatives, they were likely to have northwestern European heritage. If three-piece suits were not required, then one must say they were popular.

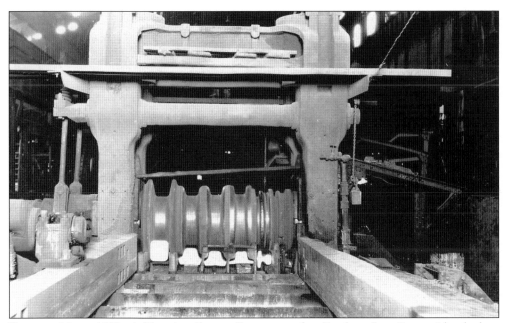

ROLLING MILL, 1929. A 35-inch rolling mill was moved to Steelton from Staten Island when Bethlehem Steel bought the Steelton plant from Pennsylvania Steel in 1916. When the mill was at Staten Island it was used mostly to roll structural steel such as I beams and channels for many of New York's skyscrapers. In Steelton it was always used as a roughing mill when rolling billets or rails.

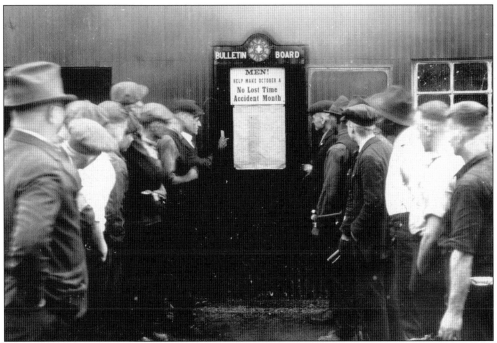

SAFETY FIRST, 1922. Steelworkers, probably on instruction, pay attention to the plant's "Safety First" bulletin board in October 1922. Even though it was dangerous work, John Yetter believed that the company's safety efforts over the years must have protected and saved uncounted lives.

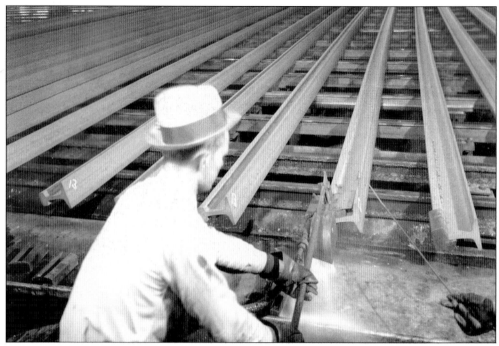

HARDENING RAILS, 1937. A worker with a tool hardens the ends of rails at the Bethlehem plant in 1937. Skilled work was most often the province of English, German, or Irish workers; unskilled work was assigned to the latest immigrants or blacks.

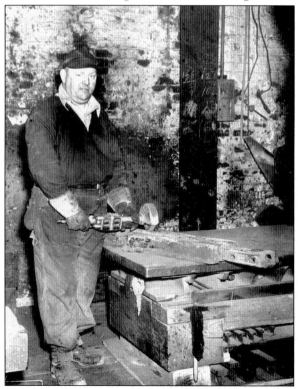

THE STEEL FOUNDRY, 1944. Harold Hiler is grinding a mine frog for use in the trackwork of a coal mine. The gritty photograph portrays the gritty conditions of work in the mill. For the purpose of conveying that atmosphere, black-and-white photographs may be more telling than any color shot.

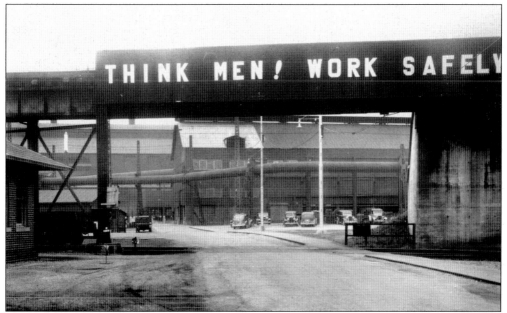

THE GATE TO THE MILL, 1938. In the middle of the borough was the Swatara Street Entrance, No. 3 Gate, in 1938. Not many American towns have an entrance to the workplace directly across the street from where men live. They could not miss the injunction to "Think" and "Work Safely." Compliance would be good for the company and them too. The reference to "men" was removed later in the century as women joined the workforce.

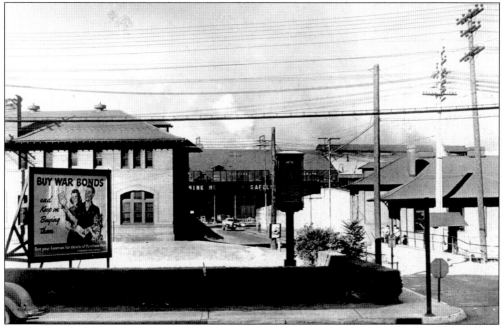

THE DISPENSARY AT THE ENTRANCE, 1942. The building behind the 1942 "War Bonds" billboard at the Swatara Street entrance is the steel plant's dispensary, where Dr. Andrew J. Griest treated workers for 40 years until his retirement in 1957. His work at the plant was in addition to his private practice in Steelton, located at the corner of Second and Pine Streets.

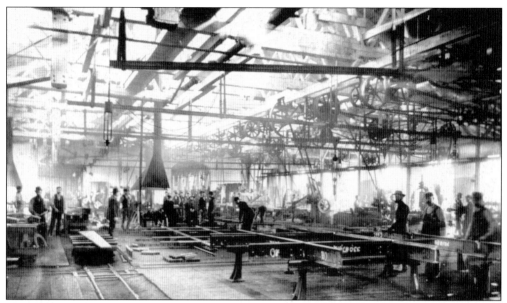

THE STEEL FOUNDRY, 1945. The interior of the frog and switch special workshop, where railroad switches were made, is filled with racks, tables, and machines. Light streams in from the roof and walls. There can be beauty in such great spaces, like a kind of industrial Grand Canyon, but no one is there for the scenery. When the Immigration Commission questioned foreign-born workers in 1910, the overwhelming majority said they came to America for the money, and a fair number went back to Europe after they got what they wanted here.

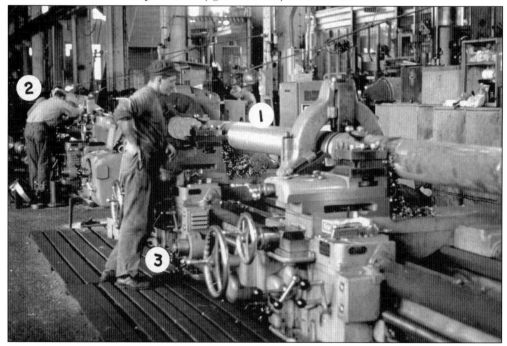

THE MACHINE SHOP. Harold L. Kerns (3), one of John Yetter's associates in collecting Steelton's history, is shown working at a lathe in the West End Machine Shop at Bethlehem Steel. This lathe could handle material several feet long

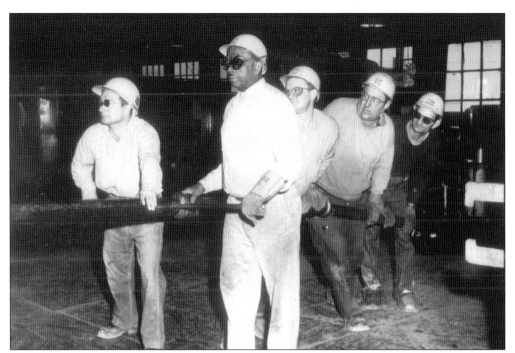

CHARGING THE FURNACE, 1963. Acting in concert, a gang charges the furnace at the steel foundry at Bethlehem Steel in 1963. At these furnaces thousands of castings were made, such as frames for oceangoing oil tankers.

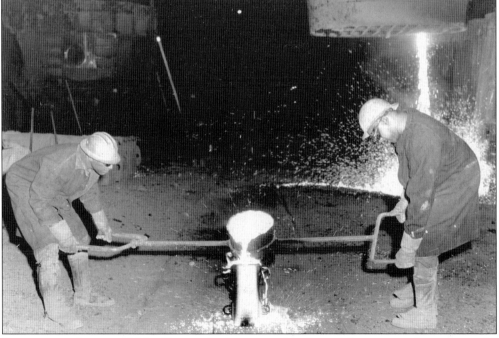

POURING AN INGOT, 1960S. Two steelmakers, eyes, hands, and feet protected, pour a model steel ingot with a hand ladle in the 1960s. The ingot was sent to the Batelle Memorial Institute to mark a second century of steelmaking.

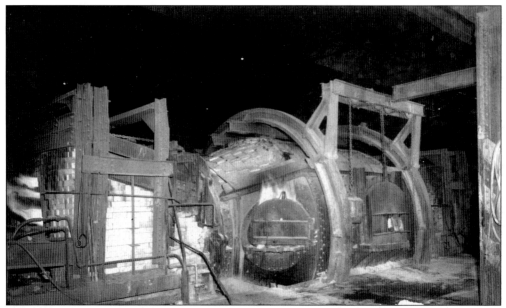

"LAST HEAT" FROM NO. 92, 1963. No. 92 furnace at Bethlehem Steel was used for the last time on March 11, 1963. No. 91 was operated for seven weeks longer. Both were replaced with two new and much smaller electric furnaces that "came on stream" in May.

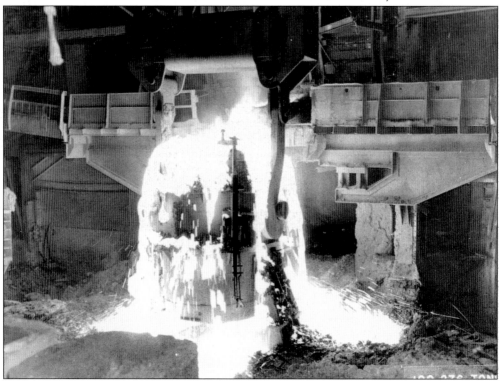

STEELMAKING: THE CLASSIC IMAGE, 1965. Bethlehem Steel's Steelton plant set a production record at its open-hearth department in March 1965. That month it made 100,276 tons of steel, just this way.

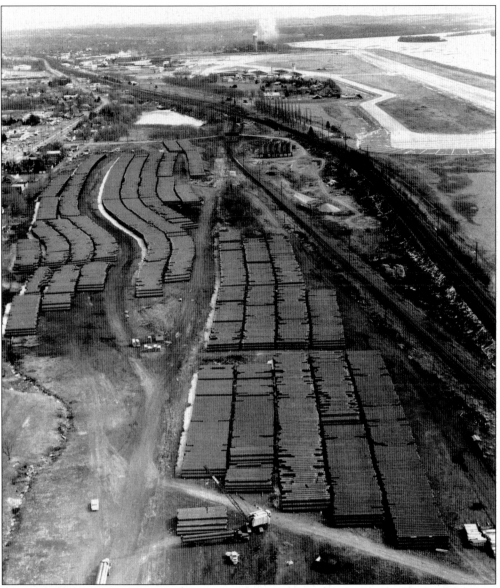

STACKS OF PIPE, C. 1965. This aerial view shows 96,000 tons of submerged arc welding pipe stacked three high along the shore of the Susquehanna River about 1965. The mill made pipe for the Alaskan pipeline.

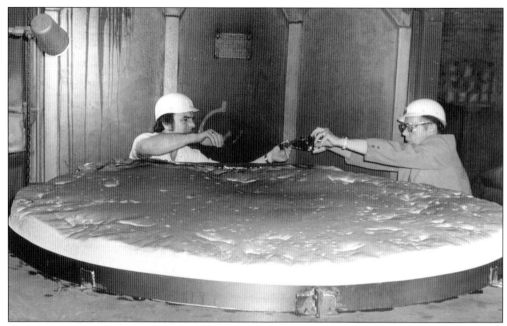

BAKING AT THE FOUNDRY, 1976. Ken Brubaker (left), chief baker, and Albert S. Schmidt Jr., Capital Bakers, inspect the world's largest hamburger bun baked at the Steelton foundry core oven in 1976. Seven feet across and made of 376 pounds of dough, the bun was prepared as an advertising gimmick for a fast-food chain opening a new facility in Baltimore.

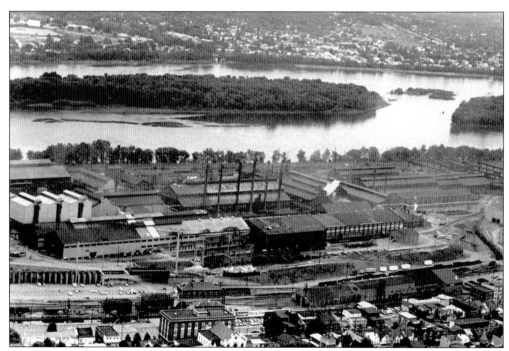

STEEL FROM ON HIGH, 1975. An aerial view shows the Bethlehem Steel plant's west end in 1975. Front Street separates the borough's business district from the canal, the railroad tracks, and the plant. In the distance is Bailey's Island.

Two

STREETS AND
BUSINESSES

RESIDENTIAL STEELTON. The viewer looks at the borough's residential section from the west side toward Cottage Hill. In the flatlands of the west side lived Bulgarians, Croats, and Serbs; in the highlands of the west side were native-born whites, Irish, and Germans. The bridge across the canal was at Trewick Street.

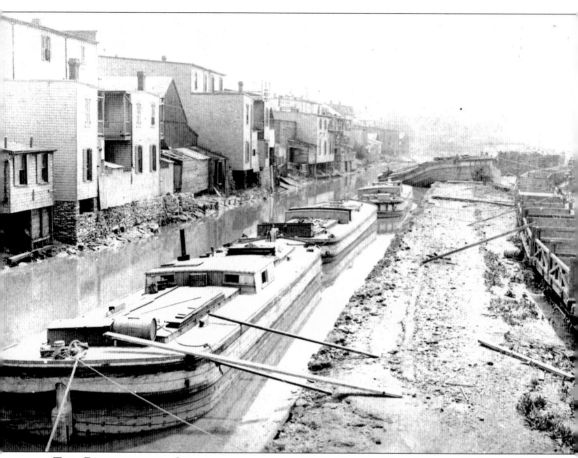

THE PENNSYLVANIA CANAL DURING THE 1889 FLOOD. The Eastern Division of the Pennsylvania Canal, completed in 1828, connected Philadelphia with Steelton and was used to transport products to and from the plant before the 20th century. Among the businesses served by canal boat was the company store, the Steelton Store Company, which sold stoves, wood, and coal in addition to foods. Eclipsed by the railroad (cars on tracks are visible on the right) and damaged by the 1889 flood, the canal stayed in operation until 1900. Even after the canal boats stopped running, townspeople remembered fishing and skating on it; ice was harvested from its frozen waters.

Pennsylvania Steel Swatara Street Entrance, 1911. This 1911 view looks out from the plant, with Front Street, unseen, running left to right. The canal in the foreground is the remnant of the Pennsylvania Canal that once ran through Harrisburg and the mid-state. The company was still able to make use of it. On the building to the left, note Coca-Cola's advertisement aimed at the workers. Also, at the top of the building to the right, signs show that Buffalo Bill's Wild West Show is coming June 9.

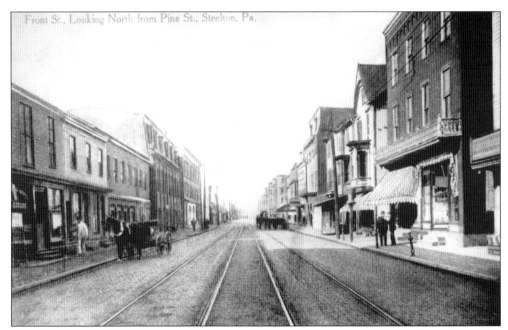

DOWNTOWN STEELTON. The photograph shows the 100 block of Front Street, looking north toward Harrisburg from Pine Street in the early 1900s. Tracks carried trolleys through town, but horse-drawn wagons used the wide main street too. Four-story buildings were the norm. Electrical lines overhead are barely visible.

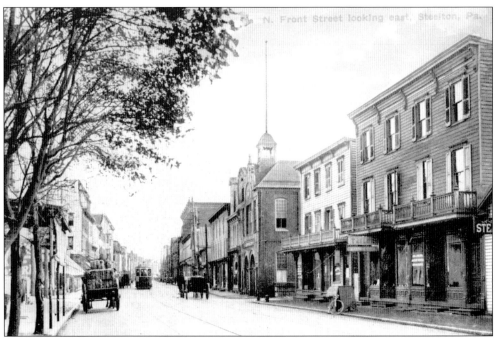

FRONT STREET, U.S.A., C. 1920. The view, about 1920, looks south on North Front Street below Angle Avenue. The industrial basis of the borough is invisible; this could be a small town in Iowa. The Susquehanna River and the mill run behind the buildings on the right.

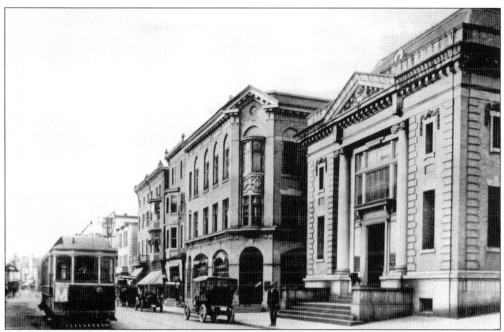

FRONT AND LOCUST STREETS, C. 1903. The scene looks north on Front Street at the Locust Street intersection, around 1903. The relatively ornate Steelton National Bank building was evidence that there was money in town. Today there are plans to revitalize shopping downtown. In fact, the bank itself is becoming something else.

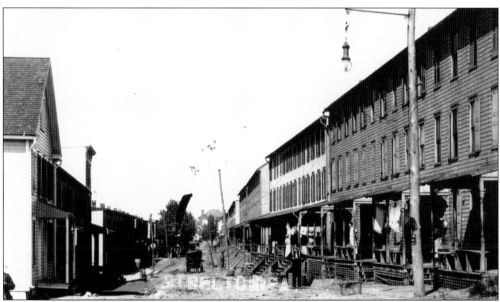

THE LITCH HOUSE. Located at South Fourth Street, looking north to Highland Street from below Dupont Street, this rare photograph shows dwellings known as the Litch House. Mr. Litch owned the dwellings and rented them to married couples, who often sublet rooms to men working at the mill. The same room might be rented as sleeping quarters to two men who worked different shifts.

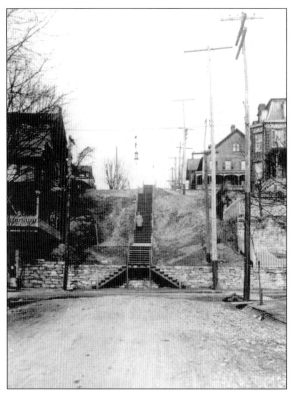

THE WOODEN LOCUST STREET STAIRWAY. Referred to as "the Magnificent Staircase," the Locust Street Stairway was constructed to promote community pride and "to get from Second to Third street," wrote Yetter. Before these stone steps were built in 1911 by the Men's League of Steelton and local contractor Carl Ballbaker, there were wooden steps coming down the borough's steeply banked terrain to the main street and the river. The stone stairway was renovated in 1992.

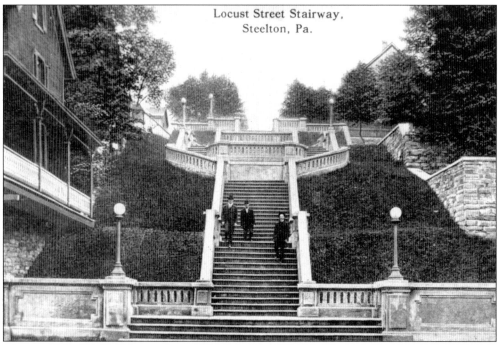

Locust Street Stairway,
Steelton, Pa.

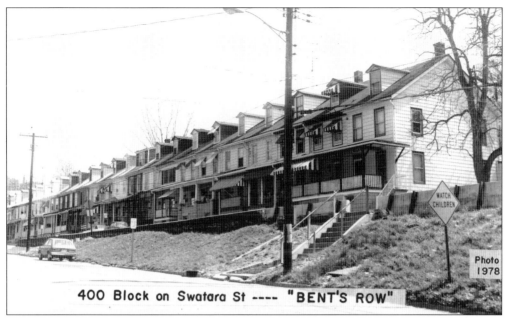

400 Block on Swatara St ---- "BENT'S ROW"

Photo 1978

BENT'S ROW, 1978. This picture taken in 1978 of houses in the 400 block of Swatara Street exemplifies the company housing established by the Pennsylvania Steel Company for its workers in the late 19th century. The line of houses were known by residents as Bent's Row after Maj. Luther S. Bent, who became superintendent of the company in 1874 and rose to be company president.

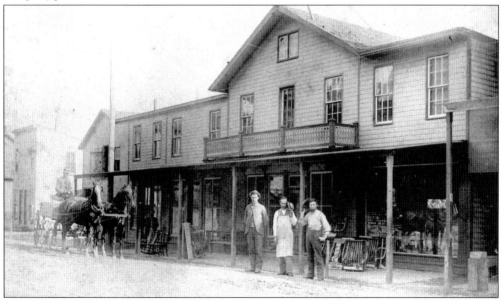

DUNKLE'S STORE, C. 1880. Men doff their hats to the photographer taking a shot of Abram B. Dunkle and Company furniture store on the 100 block of North Front Street. It was the location for the first meeting of the newly incorporated Borough of Steelton in 1880. At the time of incorporation, Steelton had around 2,500 residents and the Pennsylvania Steel Company was the leading business. The frame building was replaced before 1900 by a four-story building used as a box factory.

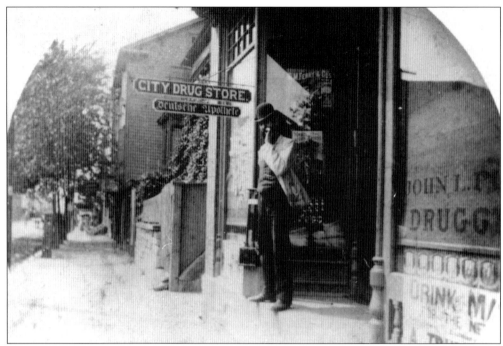

CITY DRUG STORE. "Dr." John L. Porr smokes in front of his City Drug Store (German signage included) at 147 North Front Street around 1888. The year after graduating from pharmacy school in 1887, he opened the establishment. He remained an active druggist for almost 60 years, and in 1955, photographs of him and his landmark store appeared in newspapers across the country. Three generations of Porrs did business there, including John W. Porr Sr., shown filing prescriptions the old-fashioned way. The pharmacy lasted until the calamitous flood of 1972.

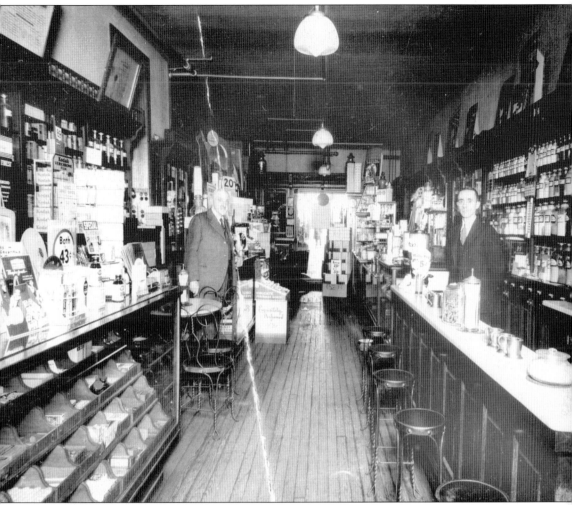

INTERIOR OF PORR'S DRUG STORE, C. 1930. On the right is an elegant soda fountain, a bygone feature of many drugstores. The store was known for specializing in herbal and folk medicine, such as blood root for coughs, skunk cabbage and dandelion root for indigestion, and leeches for swollen eyes. John W. Porr Sr. packaged his own cough drops and athlete's foot lotion.

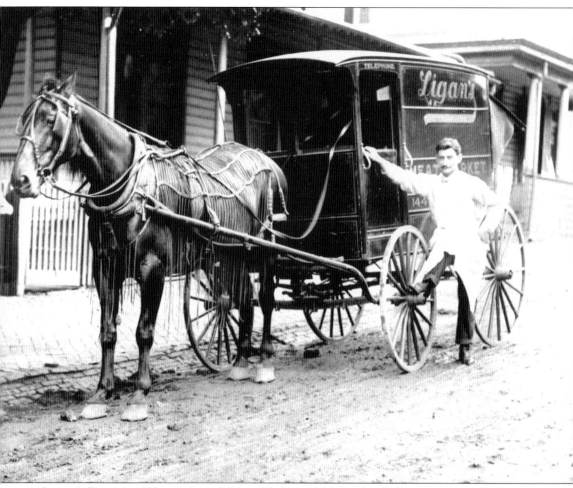

LIGAN'S BUTCHER WAGON. Ligan's Meat Market at 144–148 South Front Street used a butcher wagon, pictured here in 1905. Ligan's operated at its Front Street location for a quarter century and was followed by the Eckels brothers.

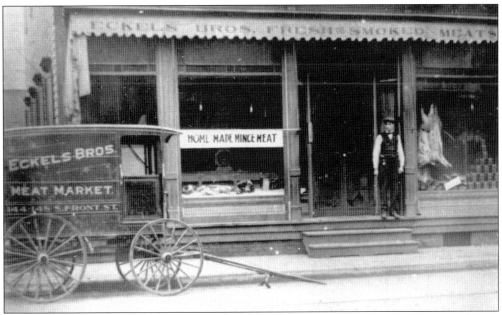

ECKELS BROTHERS MEAT MARKET. The Eckels brothers opened their meat market at 144–148 South Front Street in the early 20th century and delivered meats in a butcher wagon, which can be seen in front of the shop in this photograph. The brothers proudly advertise their homemade mincemeat in the window. Drawing on German immigrant traditions, mincemeat was a variant of sausage made with bits of meat, dried fruit, and spices associated especially with central Pennsylvania folk traditions. The photograph of the shop's interior shows a pearly-white environment.

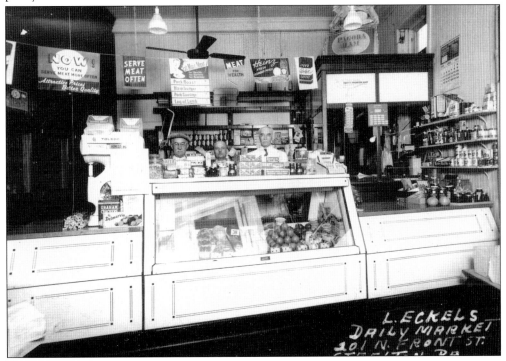

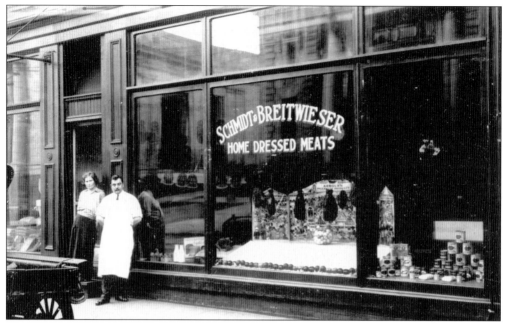

SCHMIDT AND BREITWIESER BUTCHER SHOP. An unidentified butcher stands outside the shop. Before the supermarket, the butcher was an independent provider of a vital commodity. Like the baker, if not the candlestick maker, he was also a folk figure in the community.

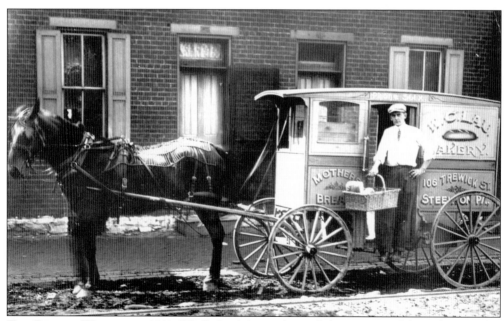

THE BAKERY WAGON, C. 1911. W. C. Lau's horse-drawn bakery wagon delivered on muddy streets about 1911. The bakery was located at 106 Trewick Street. The bread man is Les Rhodes, carrying loaves of Mother's Bread in his basket. Later he was a popular driver for the Manbeck Baking Company and in 1957 was honored for 42 years of service.

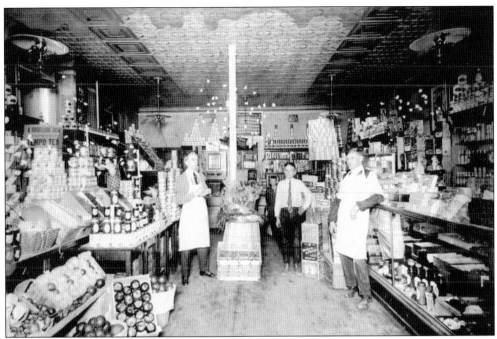

POLLECK'S GROCERY STORE, 1920. Dan Polleck, standing on the left, was a Harrisburg grocer born in 1879 who in 1920 opened a store on North Front Street in Steelton before the age of supermarkets and after the 19th-century heyday of open markets. A nod to the old-fashioned general store was a wooden barrel in the store's center. Along the back wall are advertisements for Pride Washing Powder and the National Biscuit Company, two products heralding mass distribution to consumers. Dan's son Tom managed the grocery through the supermarket era but finally succumbed to pressure from the large chains and closed the shop in 1967.

FRANK WIEGER'S GROCERY, 1902. The event that gave rise to this photograph is the 1902 flood. Its effect can be seen with the barrels immersed in the floodwaters. A number of grocer Frank Wieger's 11 children pose on the steps of the store. An immigrant from Germany, Wieger established the store in the late 19th century on the town's old west side before moving the business to North Front Street and passing the management on to his son Herman.

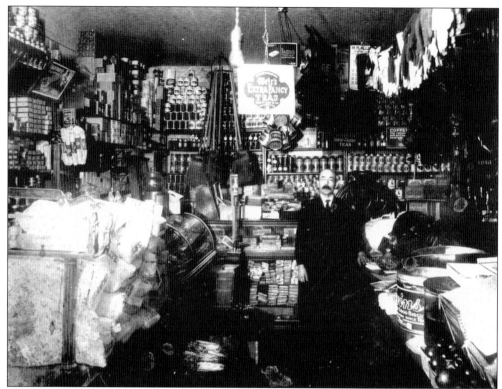

ZIMMERMAN'S GROCERIES AND THE BLACK AND WHITE STORE. Philip A. Zimmerman's well-stocked grocery store stood at 41 South Second Street about 1914. Other grocers were Beidel's, Bryant's, Dundoff's, Polleck's, Wieger's, and Marsico's. The Black and White Store, with clerks and potbelly stove at the ready, was located at 183 North Front Street in 1925. Jim Bryant, the manager, is in back of the counter. Later the A&P chain store took over this prime location on the main street.

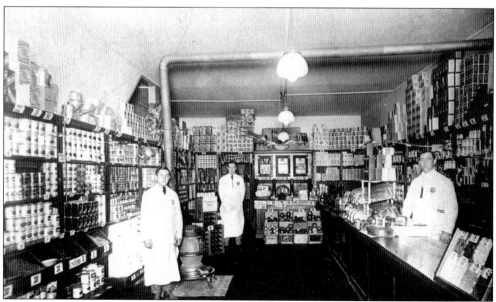

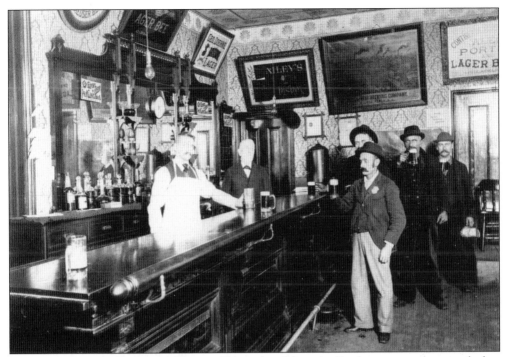

ORIGINAL BAR AT BESSEMER HOUSE. Taverns and bars in Steelton were numerous before Prohibition and served social functions in addition to dispensing beer and food. They often were places to make ethnic connections and share news of the steel mill. One of the best known was the Bessemer House, established in 1901. The growth of the town between 1901 and 1920 when its bar operated is indicated by the expansion of the bar in 1912, pictured here. The bar was also a sponsor of a competitive baseball team. The Bessemer name is significant because the mill was an early user of the Bessemer converter.

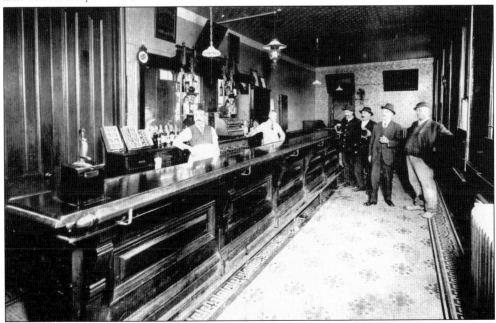

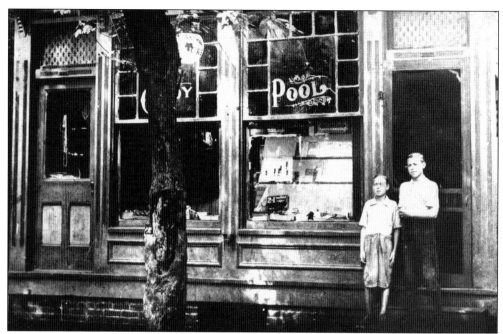

YETTER'S CANDY STORE AND POOL ROOM, 1918. Maurice and Joe Yetter, sons of Leroy "Chummy" and Agnes "Maggie" Yetter, stand in front of Yetter's Candy Store and Pool Room at 307 Myers Street about 1918. The pool table was on the second floor. In 1884, George N. Hartman had a barbershop at this address. In 1908, Hartman was selling ice cream here and later sold it to Leroy Yetter. The ice-cream business and "Chummy's Home Made Root Beer" flourished during the 1920s. After Prohibition was repealed, the confectionary became a beer garden.

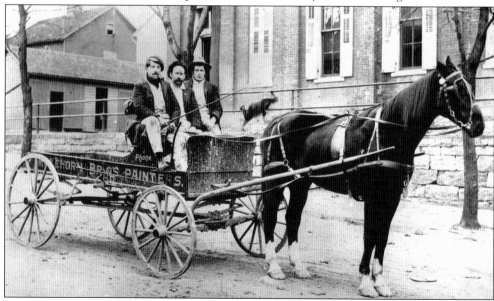

MALEHORN BROTHERS PAINTERS, 1912. Omri (left with pipe), one of the Malehorn brothers, leaves his shop and residence, pictured in the background, on Lincoln Street. The wagon stands in front of the Hygienic School for African American elementary school children, erected in 1881, on Bailey Street between Ridge and Adams Streets.

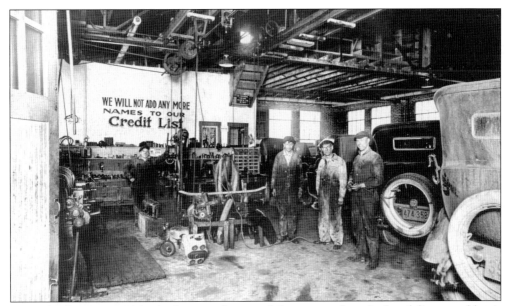

LAMKE'S GARAGE, 1923. A glimpse of automobile garages that displaced livery stables is captured in this photograph of Lamke's Garage on South Front Street. The garage's owner, Fred Lamke, stands second from the right. The grimy mechanics were working on a now-rare Velie automobile made in Illinois from 1908 to 1928. The sign on the back wall emphatically declared the desire for cash from customers before credit cards came into prominence later in the century.

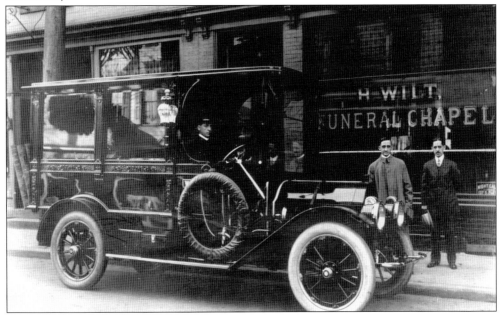

WILT FUNERAL CHAPEL. Lee and Russel Wilt stand in front of the funeral chapel on South Front Street established by their father, Harry, in 1886. The occasion for the photograph was to feature their new hearse with the steering wheel on the right that replaced horse-drawn vehicles. The sons took over the business from their father in 1911 and continued his promise to honor the many ethnic funerary customs of the town's residents.

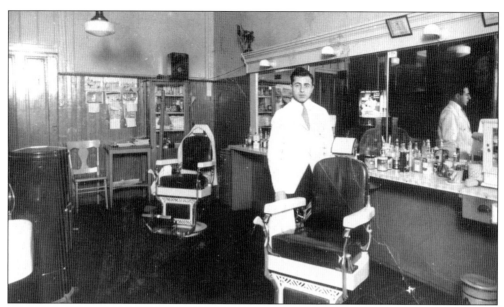

VINCE'S BARBER SHOP, 1935. Barbershops were social centers for men as well as places to get a shave and a haircut during the 20th century. In Steelton, a place to go for over 40 years was Vince's Barber Shop on South Front Street. Pictured here is owner and operator S. Vincent Lappano. A favorite subject of conversation was local sports, and Lappano posted pictures of Steelton teams in action along the back wall. Like other small business leaders, Lappano was active in civic and fraternal groups. He was president of the local St. Michael's Lodge and the charitable St. Vincent DePaul Society and a member of the Knights of Columbus and the Steelton Italian Club.

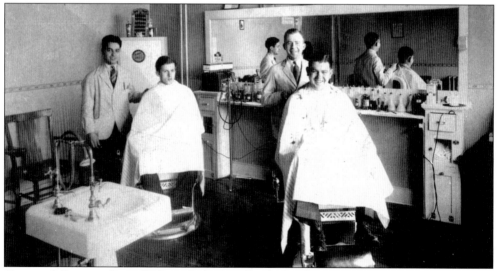

CAPELLO'S BARBER SHOP. Walter "Huck" Capello's barbershop opened in 1934. Huck is pictured here on the right, with his customer Bill Capello Sr.; barber Ernie Greco is on the left, with his customer Budd Stabneau. A year later Huck relocated to 32 North Front Street, a few doors away. In the 1936 flood he had three feet of water in the shop. Yetter's photograph notes state that Capello spent just $10 for a chair, $45 for an electric water heater, and $8 for a linoleum rug to get started. He once cut Ted Williams's hair when both were in the marines in Hawaii.

48

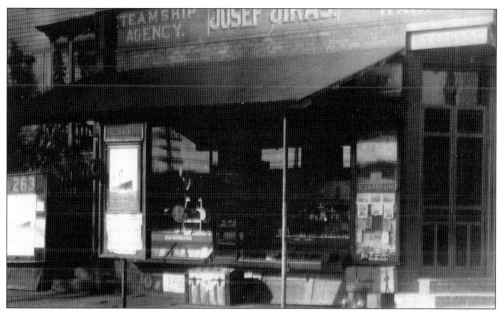

EXTERIOR, JOSEF JIRAS STORE AND STEAMSHIP AGENCY, 1909. Josef Jiras's newly opened store has signage in Serbo-Croatian as well as English, reflecting the influx of immigrants from southeastern Europe attracted to jobs in the steel plant during the first two decades of the 20th century. In addition to speaking Serbo-Croatian, Jiras was reportedly able to conduct business in 11 other languages with Steelton's residents of various national backgrounds. Jiras's store at the corner of Front and Chestnut Streets advertises ships used for passage and has a typical steamer trunk outside. One can also see religious articles in the shop window.

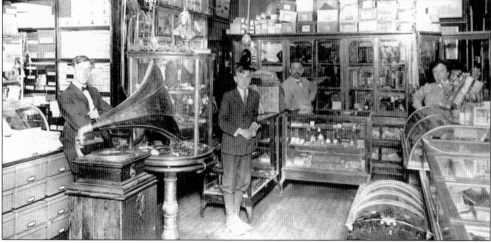

INTERIOR OF JIRAS STORE AND STEAMSHIP AGENCY, 1909. The proprietors Josef and Frances Jiras are shown with their sons Edgar and Eugene in their newly opened store catering to Steelton's many immigrants. Luggage lines the shelves above the cases, and musical instruments, especially the accordion favored by ethnic bands, are on sale behind Josef. Edgar on the left stands behind a new phonograph player using the 10-inch, double-sided disc system popularized by the Victor Talking Machine Company. Immigrants could purchase music from their homelands as well as hear American popular artists. A few years later, the Jirases installed a listening booth in the corner on the left to allow customers to hear records they wanted to purchase.

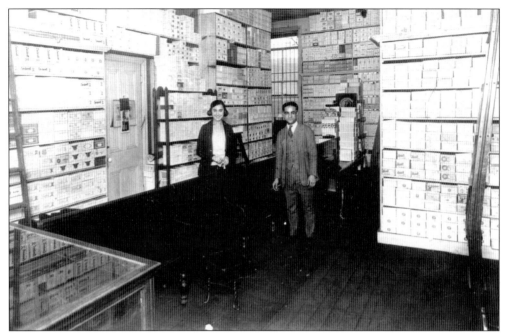

THE SHOE STORE. David Morrison's Family Shoe Store was first located at 4 South Front Street in the 1920s and later at 19 North Front Street. His brother Louis also worked in the store. When David died, his son Al operated the business until the Agnes Flood of 1972, an event that forced several Front Street businesses to close.

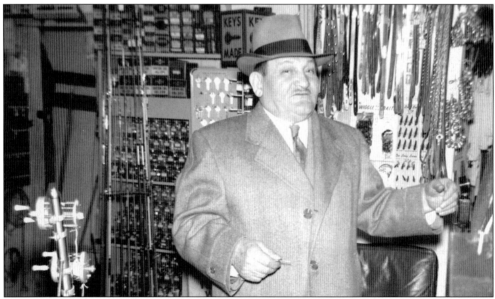

BARRY BOYS' STORE, 1955. Joe Silver appears to want a key duplicated at the Barry Boys' store on South Front Street in 1955. The Barry Boys were Morris and Samuel Barisch, two of several Jewish merchants in Steelton, whose variety store featured automobile accessories, hardware, sporting goods, and toys. In 1910, there were 85 immigrant businesses in Steelton, 45 of them operated by Jews from Poland and Russia. Several prominent Jewish families in Harrisburg got their start in Steelton. (Courtesy of Susan Silver Cohen.)

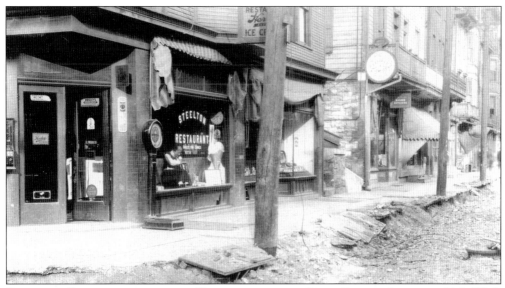

STEELTON RESTAURANT DURING PREPARATIONS TO PAVE FRONT STREET, 1926. With increased automobile traffic tearing up Front Street during the 1920s, the borough government replaced the old cobblestones with a concrete road, installed new curbs, and erected 112 electric light standards. Pictured here at the southeast corner of Front and Walnut Streets is the Steelton Restaurant, advertising in its window that it provides "tables for ladies." Hershey's ice cream was a featured product; before the era of electric freezers, shops kept the ice cream cold in tubs with ice and salt.

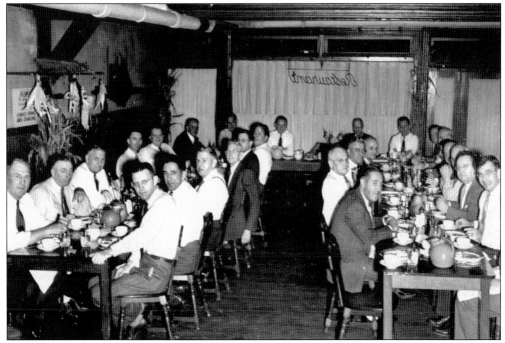

SUPERVISORS AT SHELLEY'S. Some Bethlehem Steel supervisors attend a "Harvest Feast" at Shelley's Restaurant in Steelton. At the end of the head table in the rear of the room, far right, is general manager Frank Robbins.

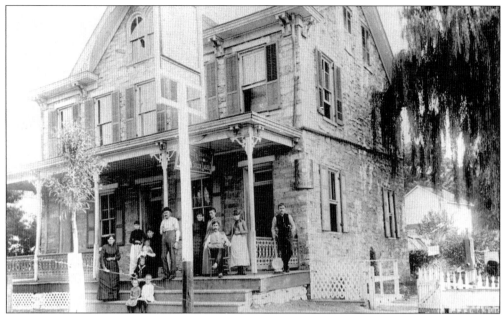

HALF WAY HOUSE HOTEL, 1888. Built in 1829, the Half Way House Hotel operated as a stagecoach stopover in the 19th century. The photograph, taken in June 1888, shows the Jacob Noll family posing on the porch. The young man leaning against the railing has a banjo to play and a straw hat to wear. About 1901, Thomas J. Nelley, whom Yetter calls "Steelton's all-time leading Republican politician," took over the building.

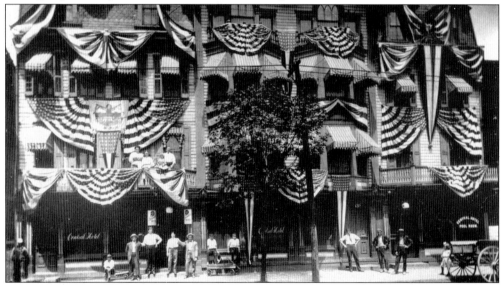

CENTRAL HOTEL. The Central Hotel, 129–135 South Front Street, stands proudly decorated, probably for a holiday around the dawn of the 20th century. Kirk and Bartram Shelley were the owners of the property, which was once two businesses, the 2nd Ward House and the Central Hotel. Sitting on the windowsill with their feet resting on their wagon are Kirk's sons, Carl and Roy. John Yetter wrote in his notes for this photograph that Carl Shelley served as Dauphin County district attorney from 1937 to 1952 and then held court as a judge. His brother, Roy, took over the hotel and managed it as Shelley's Restaurant.

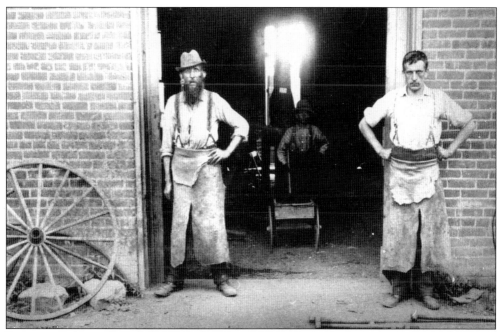

BLACKSMITHING. Two smiths look and dress the part, positioned in front of Schubauer's Blacksmith Shop near Front and Elm Streets. Their work was not industrial; it was handcraft—most likely creating and repairing metalwork for local use.

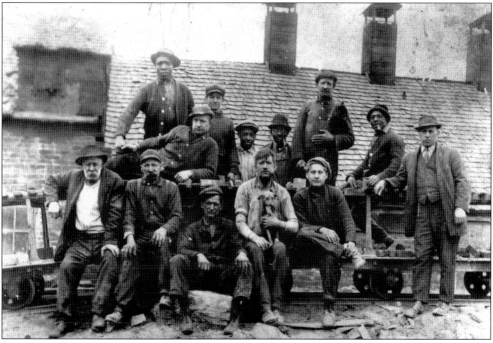

BRICKMAKING. Another workshop on the west side was the Steelton and Harrisburg Brick Company, located near the gas tank on the west side. Clay for the bricks was dug locally, first at the "clay hole" at Nineteenth and Gibson Streets and later around the steel mills. The brickmakers assembled here, with dog, seem the picture of working men.

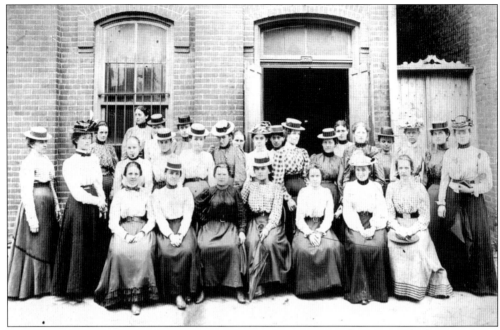

WORKING WOMEN AT THE CAPITAL SHIRT COMPANY. Not only men worked in Steelton's factories. Well-dressed distaff employees pose in front of the Capital Shirt Company at 182 North Front Street, coincidentally demonstrating the popularity of straw hats, high collars, and long skirts. The dressmaking company was organized in 1888 by Simon C. Peters.

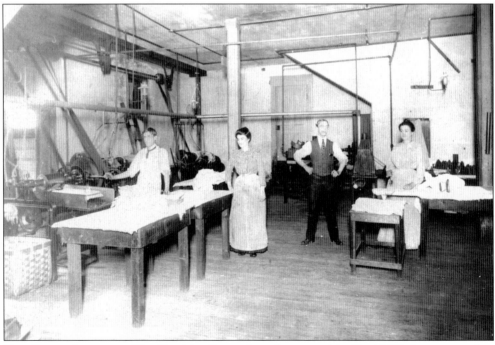

THE STEAM LAUNDRY. The Excelsior Steam Laundry, owned by David Diegle, was another business on North Front Street, located at No. 116. Customers may have been institutional users such as hotels. In Harrisburg, there were Chinese laundries in the early 20th century.

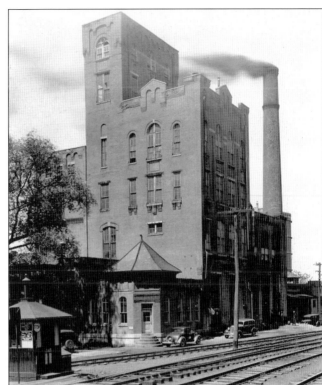

THE LOCAL BREWERY BUILDING AND WORKERS. The original National Brewery Company building was located next to the railroad tracks on the west side, a neighborhood largely destroyed by the 1972 Agnes Flood. About the time of World War I, the brewery's employees seated outside look ready to make use of their product.

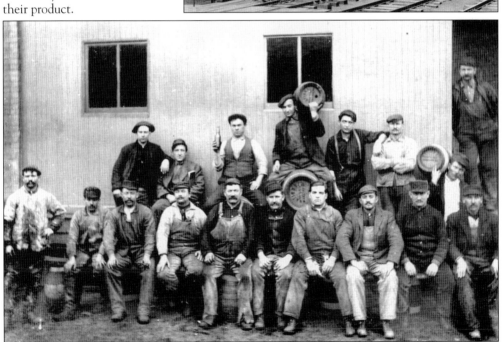

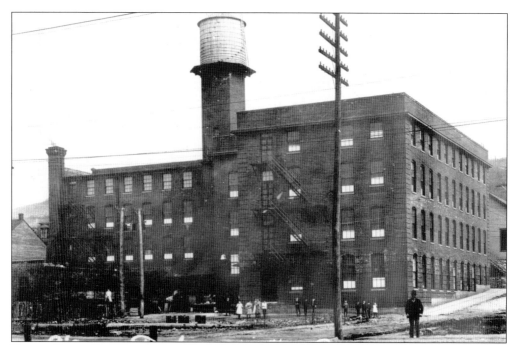

BAYUK CIGAR COMPANY FACTORY, EARLY 1900S. The steel plant was not the only industrial complex in Steelton near the Susquehanna River. During the early 20th century, the area of South Front and Washington Streets contained cigar and rope factories. Central Pennsylvania was a major cigar-manufacturing region. The Spanish-American War devastated the great tobacco plantations in Cuba during the late 1890s, creating a demand for American-grown tobacco from Lancaster County rolled into cigars in surrounding industrial centers such as York and Steelton. The industry employed 800 women who would dry and strip tobacco in the factory, while men harvested the locally grown wrappers, rolled cigars, manufactured cigar boxes, and transported the merchandise. With the decline in cigar consumption and rise in cigarette usage as the 20th century advanced, the factory closed and was used as a flea market during the 1970s until a fire devastated the building in 1976.

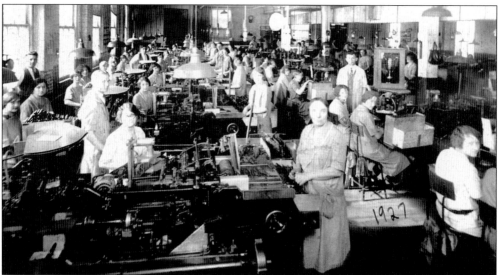

Three

ETHNIC AND RELIGIOUS LIFE

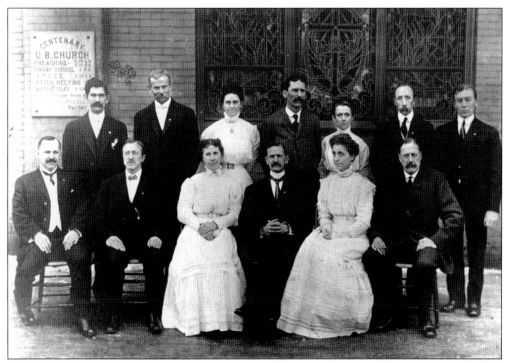

CENTENARY UNITED BRETHREN CHURCH, C. 1910. Members pose properly in front of the Centenary United Brethren (UB) Church about 1910. The plaque in front announces there would be preaching twice on Sundays, morning and evening, and Sunday school. Prayer meeting was on Wednesdays. The pastor was the Rev. E. A. C. Bossler. The UB Church was rooted in Germany, and the Germans were among the first to settle in Steelton.

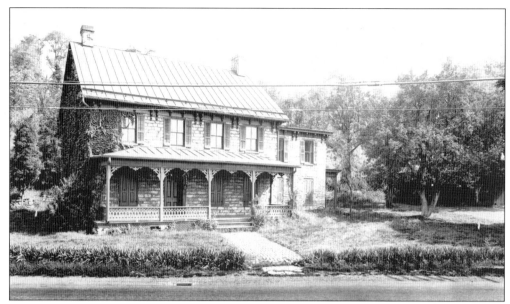

FRANTZ FARMHOUSE, 1931. With the razing of this house during the 1930s, the remnant Pennsylvania German farming legacy of the region was hardly visible in the town's industrial landscape. The Pennsylvania German influences are evident in the off-center entrance, summer kitchen, and bank barn to the right. The Pennsylvania Steel Company bought the farmland owned by the Frantz family at this site for its frog and switch department (see cover), and the building was eventually demolished to accommodate the state highway.

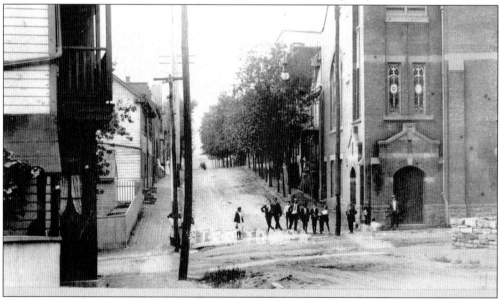

MONUMENTAL AFRICAN METHODIST EPISCOPAL CHURCH, 1907. Black residents organized the Monumental African Methodist Episcopal Church in 1871 and used a schoolhouse at the foot of Adams Street for services. The church building pictured on the right was completed in 1907 on land donated to the congregation at Second and Adams Streets. The photograph shows a brick walkway laid across the intersection to control dust and mud for pedestrians before Steelton streets were paved.

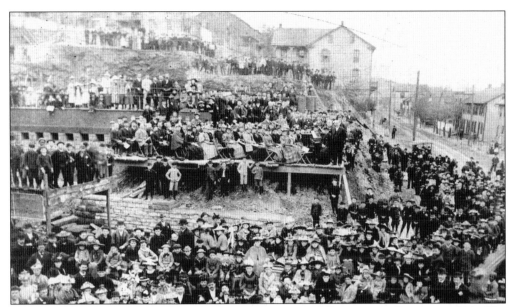

CORNERSTONE CEREMONY FOR ST. JOHN'S EVANGELICAL LUTHERAN CHURCH, 1893. The Lutheran Church was organized in 1875 and a small building constructed to house worshipers at Locust Street and River Alley. Pictured here is the ceremony for laying the cornerstone of a larger church at North Second and Pine Streets. It appears that an organ was brought in for the dedication and placed on the platform. The building was completed in 1894 and consecrated for Sunday services on July 15.

CORNERSTONE FOR THE METHODIST EPISCOPAL CHURCH, 1912. Congregants gather for the laying of the cornerstone for the new Methodist Episcopal church in 1912 at the corner of Fourth and Pine Streets. Organized in 1868, the first Methodist church was built on the Pennsylvania Steel Company's grounds. The building was moved to this site in 1877 and then replaced 36 years later.

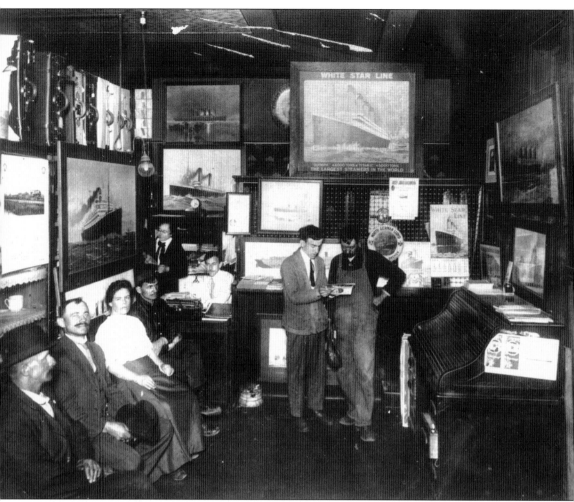

Josef Jiras Steamship Agency, 1914. Steeltonians used the office to arrange for the passage to America of family members who had remained in Europe. Steamship portraits deck the walls, including, at the top, the White Star Line's advertisement for the *Titanic*. An immigrant himself, Jiras got his start working at the Steelton Company Store and providing interpreting services for doctors administering to immigrants. He opened a grocery at Front and Adams Streets before opening the dry goods store and steamship agency pictured here.

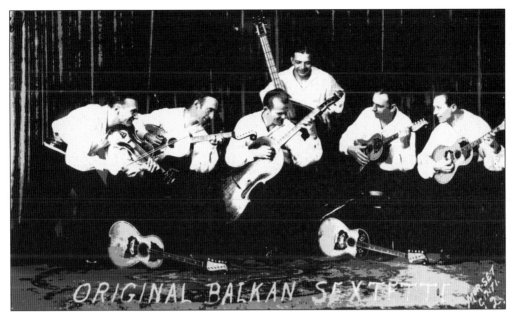

ORIGINAL BALKAN SEXTETTE. This musical group labeled the Original Balkan Sextette, probably from the early 20th century, was one of many tamburitzan bands that entertained residents with southeastern European backgrounds in Steelton. The Balkan reference was a sign of ethnic mixing, since bands developed Serbian, Croatian, Macedonian, Greek, and Romanian repertoires to appeal to their ethnic audiences. The tradition continues to the present day with local musicians who perform for dancers at church picnics in Serb Park on Eisenhower Boulevard.

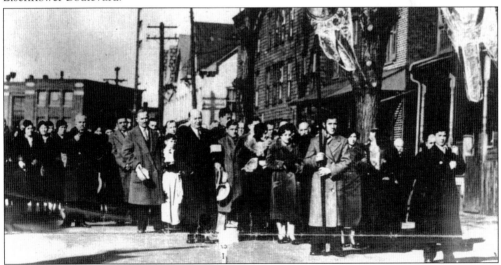

PROCESSION BY MEMBERS OF THE MACEDONIAN-BULGARIAN CHURCH, 1932. A procession toward the Susquehanna River to commemorate the Feast of the Epiphany with the custom of watching volunteers dive for a cross was an annual custom of the Macedonian-Bulgarian Orthodox Church from 1912 to 1939. The procession began at the church in the 700 block of North Front Street. Pictured here are the congregants at Main and Franklin Streets. In 1935, the Steelton observance drew media interest from "Fox Movietone News," which was shown in movie theaters across the country.

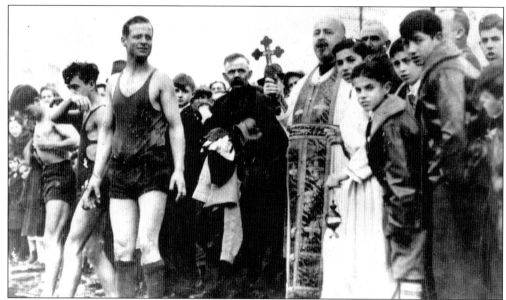

MACEDONIAN-BULGARIAN CHURCH MEMBERS DIVING FOR THE CROSS, 1934. Members of the Macedonian-Bulgarian Orthodox Church in Steelton gather at the Susquehanna River bank for a ceremony on the Feast of the Epiphany, January 19, which commemorates the baptism of Christ in the Jordan River. Volunteers dive into the icy waters to retrieve a metal cross thrown by Rev. David Nakoff. Upon the cross's rescue, four doves would be released into the air. Honor is accorded to the successful diver at a gala celebration during the evening in the church hall.

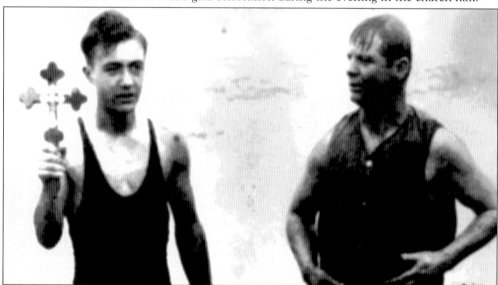

MACEDONIAN ORTHODOX DIVING FOR THE CROSS, 1935. A ritual that set apart the Greek and Macedonian Orthodox communities from other ethnic groups was the annual diving for the cross ceremony in the Susquehanna River as part of observances of the Feast of the Epiphany in January. Retrieving the cross by young men from the chilly waters was supposed to ensure a year of good luck and blessing. The man who finds the cross is cheered, and a procession carries him back to the church where a blessing service takes place. This picture shows Demo Atanasoff holding the cross in January 1935 accompanied by Spiro Mircheff.

HOLY ANNUNCIATION MACEDONIAN-BULGARIAN EASTERN ORTHODOX CHURCH. The original church was organized by Macedonian-Bulgarian immigrants, many of whom came from the town of Prilep. The church's cornerstone was laid in 1909, and the first leader was the Reverend Theophelact. The new church, located at 721 North Front Street in Steelton, is pictured here.

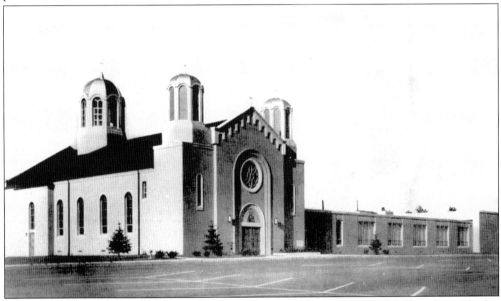

ST. NICHOLAS SERBIAN ORTHODOX CHURCH. The new Serbian Orthodox church in Oberlin was consecrated in 1968. The former building had been in Steelton. Serbian immigrants formed the St. Nicholas Lodge in the borough in 1901. In 1903, St. Nicholas Serbian Orthodox Church became the fourth Serbian parish in America. There were 2,000 members when the church was dedicated. Other social centers were a Serbian school, the Serbian Glee Club, and a Serbian Athletic Sokol. Prof. John Bodnar writes of a local celebration honoring the late King Alexander of Serbia that lasted a week and ended in a huge parade. Serbs' most important event was the Orthodox Christmas, celebrated on January 7. For that event, says Bodnar, "The festivities would last several days, with church services, pig roasts, dances, drinking, and games of strength."

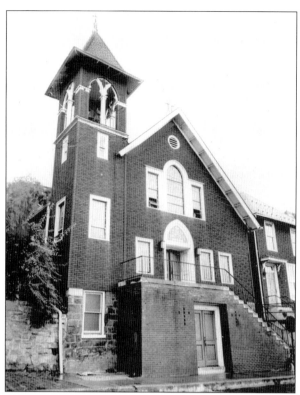

ORIGINAL ST. ANN'S ROMAN CATHOLIC CHURCH. St. Ann's formed in the early 20th century, largely composed of immigrants from the province of Cosenza in southern Italy who came to work in the steel mill. The cornerstone for the congregation's first church building at 331 South Third Street, pictured here, was dedicated on July 19, 1903. The church later moved into new quarters at Reynders and Spruce Streets. During the 1980s, with much controversy, the Catholic Diocese of Harrisburg merged St. Ann's with other Catholic churches into Prince of Peace Parish.

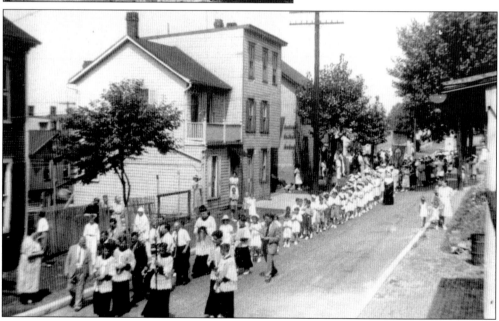

ST. ANN'S PROCESSION, C. 1930. Young members of St. Ann's Catholic Church line up in a procession on South Third Street in the 1930s. A banner at the end of the procession honored a saint, and pious onlookers would pin an offering to it. John Yetter called this "one of the most memorable practices." St. Ann's was the home church for many Steeltonians of Italian heritage.

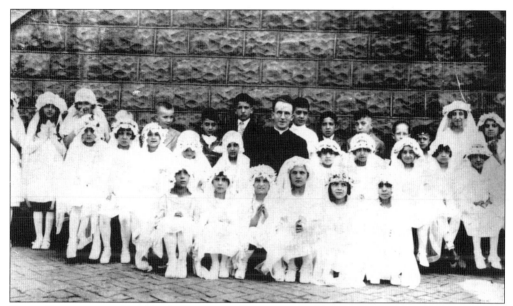

FIRST COMMUNION, ST. ANN'S CATHOLIC CHURCH, 1926. How proud the parents must have been as they watched their youngsters receive first communion at St. Ann's in 1926. The girls were dressed beautifully, and they also fully outnumbered the boys about three to one.

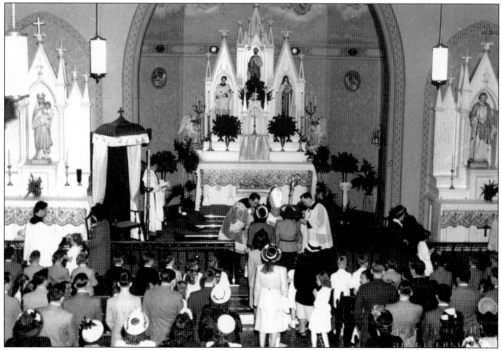

CONFIRMATION DAY, ST. PETER'S CATHOLIC CHURCH. The most profound religious ceremony in a young Catholic's life is confirmation. St. Peter's traces its background to Slovenian immigrants who came in 1883. The parish was established in 1909; the church was dedicated in 1910.

CATHOLIC MASS AT ST. JAMES ROMAN CATHOLIC CHURCH, 1943. Drawing the eyes of passersby on North Front Street was the stately tower of St. James Roman Catholic Church, dating from the late 19th century. Paralleling the large arched doorway on the exterior were arches stretching across the ceiling and behind the altar. Pictured here is a special mass on May 18, 1943, at the church in honor of the Right Reverend Monsignor John F. Stanton (1894–1961) on his silver anniversary to the priesthood. During the 1980s, the Catholic Diocese of Harrisburg closed several churches, including St. James, and combined them into Prince of Peace Parish on South Second Street. St. James's building was transferred to the Islamic Society of Greater Harrisburg, serving a growing population in the region of immigrants from India, Pakistan, Bangladesh, Sri Lanka, and Africa.

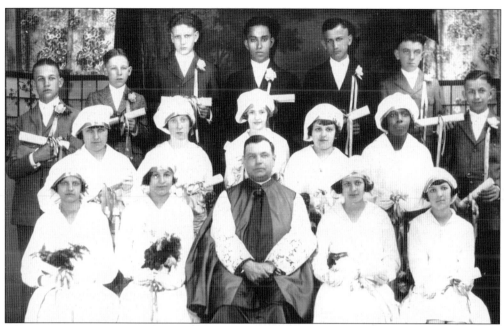

ST. JAMES SCHOOL, 1925. Eighth-grade students pose with their diplomas at St. James Catholic School in 1925. Sitting in front is Monsignor Thompson. St. James Catholic Church was attended by early Croatian and Slovenian settlers. However, they drifted away because the priest spoke English and because they chafed at the Irish domination there. They eventually convinced Rev. Joseph D. Bozic, a frequent visitor from Allegheny City near Pittsburgh, to organize a church for them, and in 1898, St. Mary's Croatian Slovenian church had its first services. However, differences over language divided the congregation, and in 1909, Slovenes established St. Peter's Slovenian Church, led by Rev. Francis Azbe, while the Croats remained at St. Mary's.

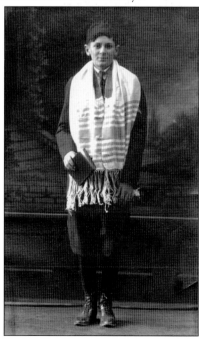

DR. SILVER'S BAR MITZVAH, C. 1923. The future Dr. Israel (I. O.) Silver completes his bar mitzvah at Tiphereth Israel, Steelton's synagogue that was organized in 1904. Born in 1909, Silver graduated from Steelton High School in 1926, from Franklin and Marshall College in 1930, and from Jefferson Medical College in 1934. He opened his practice in Steelton in 1936 and stayed for half a century, healer to its peoples and its teams. (Courtesy of Susan Silver Cohen.)

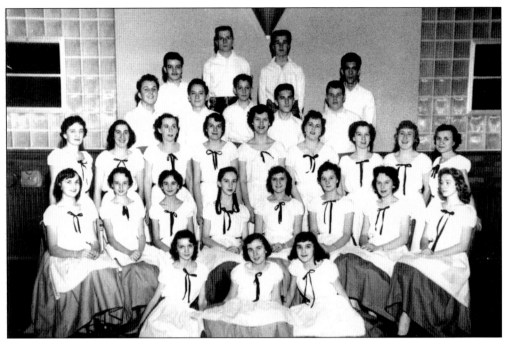

KOLO CLUB MARIAN. The Kolo Club Marian was organized in 1954, the Marian Year, by the Reverend William Primorac of the Assumption of the Blessed Virgin Mary Church in Steelton to preserve Croatian heritage. Members studied and performed Croatian folk music, songs, and dances in costumes representing their Old World heritage. The group presented an annual spring concert in Steelton and arranged programs in various locations in the United States and Canada. The two pictures show the growth of its membership from around 30 in 1955 to three times that number in 1973. Their performance is a symbol of regional ethnic unity because it is a collective circle dance in which dancers perform in ethnic costume accompanied by distinctive string instruments called tamburitza.

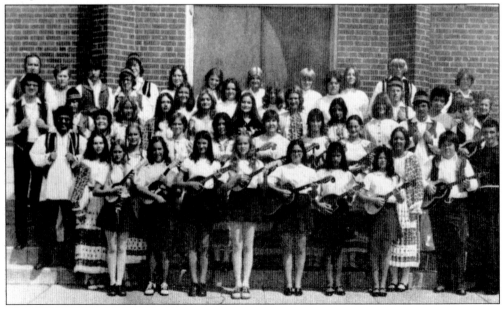

Four

CIVIC LIFE AND SCHOOL DAYS

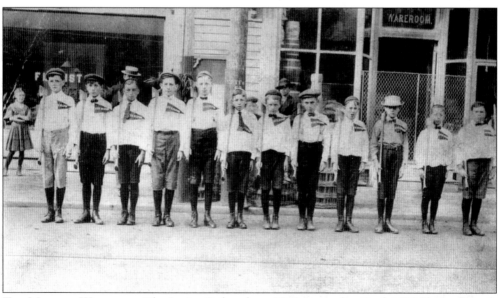

THE MODERN WOODMEN. The Junior Order, about 1905, is standing in the 100 block of North Front Street. The boys shouldered axes as if they were rifles and drilled with them. Gustav Hanson's flower shop is in the background to the left. To the right, "Wareroom" over the door identifies the hardware store of L. S. Shelly and Brothers, later Brinser and Sons Hardware Store.

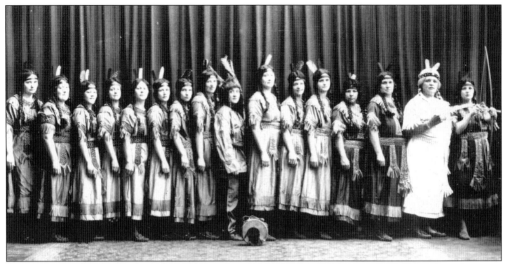

AUXILIARY, PAXTANG TRIBE OF RED MEN, 1935. Like many other American cities and towns, Steelton had numerous civic and voluntary associations—men's and women's clubs. Here, in a 1935 photograph, "dressing Indian" are members of the Swatara Council, an auxiliary of the Paxtang Tribe of Red Men. The lady in white, apparently their leader, is Ellen Aucher.

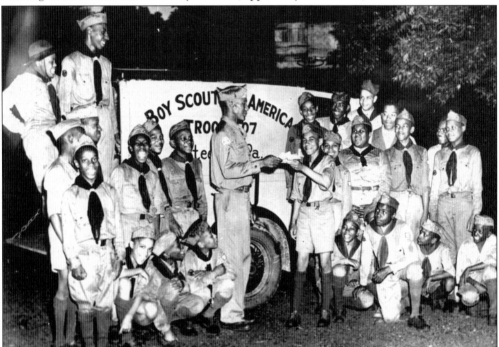

AFRICAN METHODIST EPISCOPAL SCOUT TROOP 107, 1943. Here are the completely pleased and fully uniformed members of Boy Scout Troop 107 of the Monumental African Methodist Episcopal Church, Second and Adams Streets, in 1943. The African Methodist Episcopal Church was the third church established in Steelton, organized in 1871 by African Americans who lived in Oberlin and Baldwin, as Steelton was once known. Parishioners first worshiped in a schoolhouse on the corner of Front and Adams Streets. A substantial church was built a block away in 1907. Steelton, like Harrisburg, has nearly always had a multiracial population.

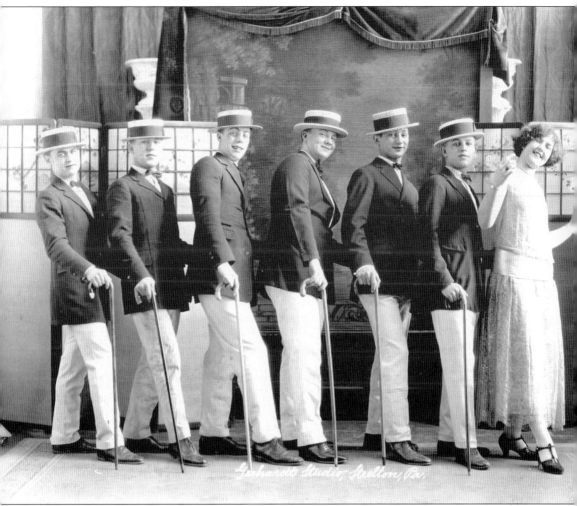

AMERICAN LEGION MUSICAL COMEDY, 1924. The high school was not the only organization producing stage productions for local entertainment. This picture shows a troupe stepping out for the American Legion in 1924. The cast decked out in fashionable straw hats and canes advertised their show as a musical comedy. The photograph was taken by Gerhardt Studio located in the 100 block of North Front Street. Adding to Steelton's musical variety before World War II was its small symphony orchestra.

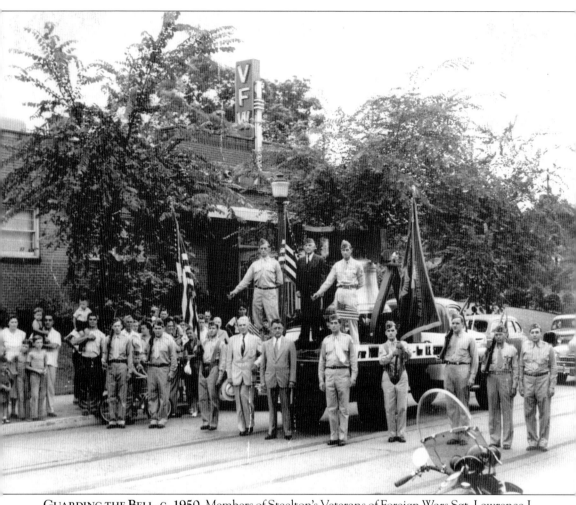

GUARDING THE BELL, C. 1950. Members of Steelton's Veterans of Foreign Wars Sgt. Lawrence L. Chambers Post 710 stand guard over a replica of the Liberty Bell mounted on a trailer on Front Street, about 1950. The bell was on tour through Pennsylvania for a Korean War bond drive. Past commander of the post Dan Crowley stands on the truck in the center; standing at the foot of the truck, between the flag bearers, from left to right, are burgess William P. Dailey, postmaster John J. "Jumbo" Verbos, and post commander Lawrence Conjar.

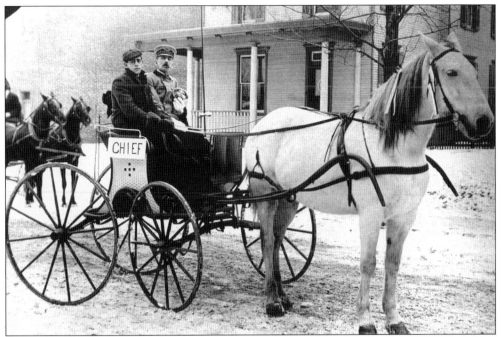

FIRE CHIEF. Steelton's first fire chief, Mr. Brinton, is riding in a buggy clearly labeling his position. Their location is Front Street above Lincoln Street, just north of the Paxtang Hook and Ladder Company. Reporting a fire at an alarm box required a key. Box 22 at Front and Swatara Streets, for example, had keys kept at Peter's Drug Store, Young Brothers' store, and E. A. Snyder's store, if one knew where to find them.

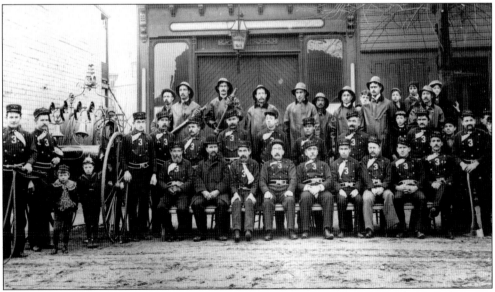

WEST SIDE HOSE COMPANY, 1898. The third fire company to be organized in Steelton was the West Side Hose Company formed in 1898 out of the former Fifth Ward Republican Club. Pictured here is the original firehouse on the southwest corner of Myers and Conestoga Streets. It was replaced by a building across the street, and the original home became a barbershop and poolroom.

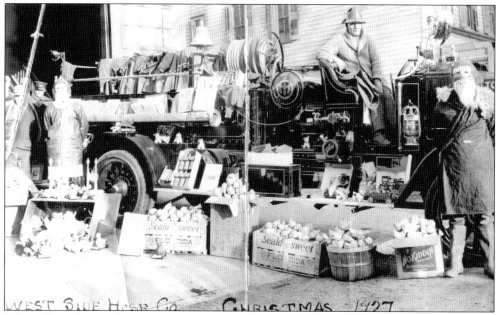

WEST SIDE HOSE COMPANY DURING THE CHRISTMAS SEASON, 1927. Santas from a neighborhood fire company show the packages and toys they will distribute for Christmas in 1927. Among the items are dog figurines, toy carts, and harmonicas. Volunteer fire companies such as West Side, Baldwin, and Citizens have been vital social and life-saving institutions in Steelton.

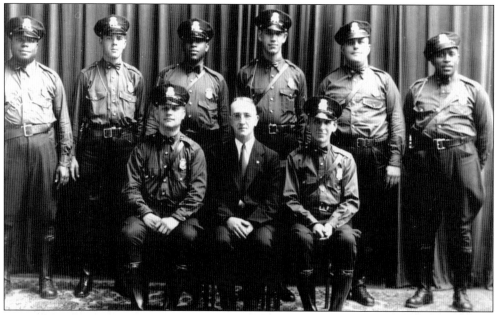

STEELTON'S POLICE FORCE, 1937. Of the eight officers pictured, three are African American and at least three are Slavic, making it possibly one of the most racially and ethnically integrated forces in Pennsylvania at that time. In the front row, left, is Chief Joseph N. Sostar, in the middle is burgess James J. Coleman, and to the right is Lt. Daniel Sullivan. Of the 13,500 residents in the borough in 1940, 2,514 were black, one of the largest ethnic groups in the town.

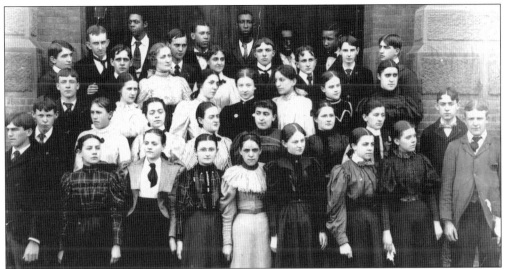

STEELTON HIGH SCHOOL GRADUATING CLASS, 1897. The photograph above shows one of the last graduating classes to have been educated in the Baldwin School on the northwest corner of Second and Walnut Streets before the Felton Building opened in 1900 at Fourth and Walnut Streets. Integrated in the class are a number of African Americans shown at the top; the dominant ethnicity at the time among the other students was German and British. The second photograph shows their reunion. Whether out of loyalty or longevity, 10 members, or one quarter, of the class of 1897 met at the home of justice of the peace Frank A. Stees (top row, second from left) in Steelton in 1947. Seated from left to right are Luella Hickman Englar, Edith Rothrock Doris, Tillie Behney Runkel, and Lydia Hotz Bennett. The second row comprises from left to right James B. Saul, Stees, Margaret Bradshaw, Florence Henderson Booser, George W. H. Roberts, and John B. Malehorn.

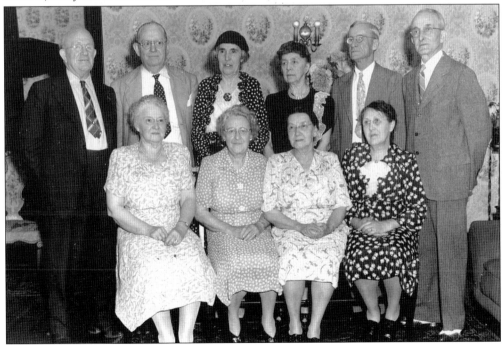

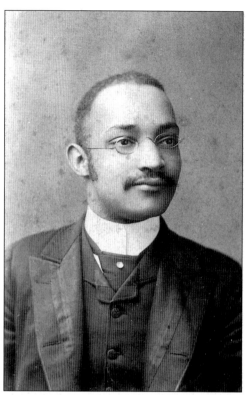

CHARLES F. HOWARD OF THE HYGIENIC SCHOOL. Charles F. Howard had the distinction in 1885 of being the first African American to graduate from Steelton High School, and a year later, he was appointed principal of the Hygienic School, a post he held for 50 years. Elementary education for black students was segregated in the early 20th century in central Pennsylvania. In 1890, black citizens protested the school board's decision to place their children in an unsuitable building, so classrooms were found in the Hygienic School, built in 1881 and named for its location on Hygienic Hill. In 1910, black parents again protested conditions in the Hygienic School. In 1914, a new Hygienic School was erected. It was demolished in 1974.

MAJOR BENT SCHOOL PLAYGROUND, 1917. Girls are shown in this photograph taken in 1917 at Major Bent School Playground learning sewing skills. Many activities divided along gender lines, such as sewing for the girls and woodworking for the boys. At the time this photograph was taken, Steelton's elementary schools were segregated. Black students attended the Hygienic School until Major Bent became integrated in the 1960s.

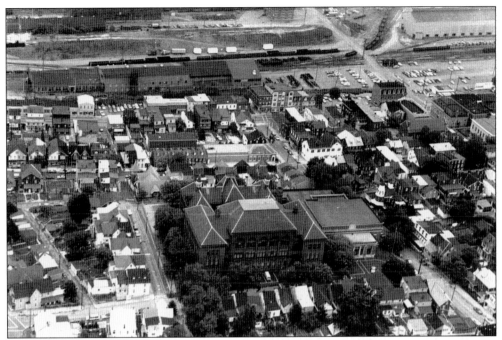

OLD AND NEW STEELTON HIGH SCHOOL. The old Steelton High School stands prominently in the midst of the borough. The design reflected the monumental status, proportions, and appearance that public buildings were expected to have generations ago. The new Steelton Highspire High School, further up the hill, likewise reflects what contemporary architects and educators think schools should look like and how they should function—more practical, more accessible, more cost-effective.

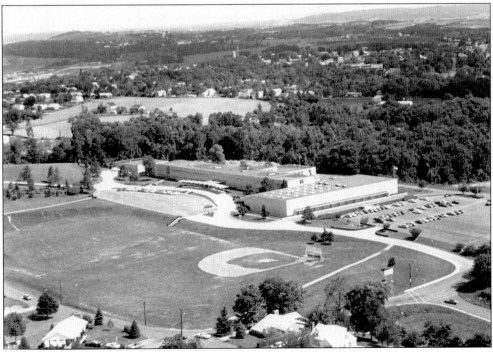

CAST MEMBERS OF HIGH SCHOOL PLAY, 1918. One of the cherished traditions in Steelton before World War II was the annual high school play. The high school's assembly hall was an impressive structure that could hold 1,200 people. Pictured here is the 1918 play showing the exuberance that ushered in the Jazz Age. Male cast members of the Steelton High School drama ham it up for the camera. The group includes one figure in blackface, suggesting a minstrel troupe theme for the production led by Garret Punch at the left with the baton.

CAST MEMBERS OF *THE SKYRIDERS*, 1919. Cast members of the Steelton High School play *The Skyriders* are seen here. The production makes reference to World War I, which had ended the year before.

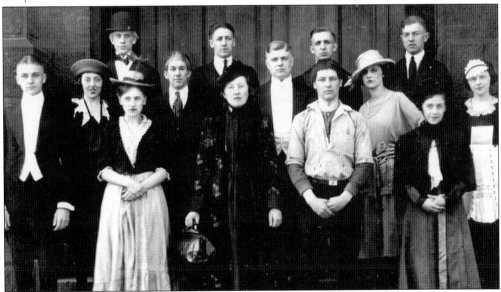

CAST MEMBERS OF *THE REJUVENATION OF AUNT MARY*, 1921. The Steelton High School seniors decided to reprise the 1907 Broadway comedy (transformed into silent films of 1916 and 1927) written by American playwright and novelist Anne Warner for their 1921 production. The farce was appealing because of its plot revolving around the hijinks of a student threatened with expulsion. The naïve, ever-loving Aunt Mary with satchel in hand was played by Catherine Livingston, and the troubled student Jack standing next to her was portrayed by Clarence Shaub.

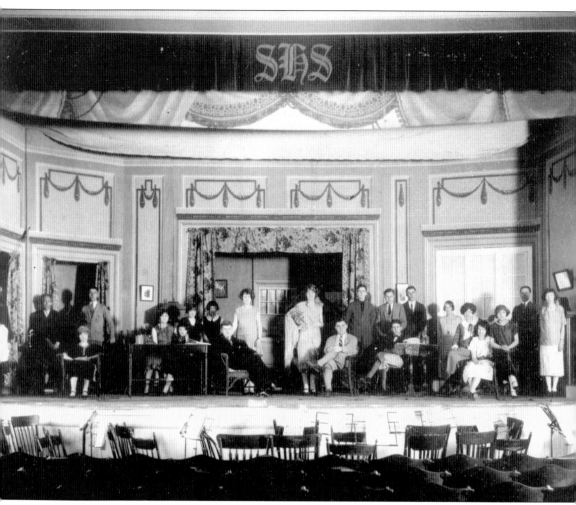

ONSTAGE WITH *THE WHOLE TOWN'S TALKING*, 1925. Unlike other senior class play photographs over the years, this one was taken inside the high school auditorium and shows the elaborate stage set. The show was adapted from the Broadway comedy of the early 1920s about a meek, law-abiding man mistaken for a ruthless gangster. In 1935, *The Whole Town's Talking* became a popular movie directed by John Ford and starring Edward G. Robinson.

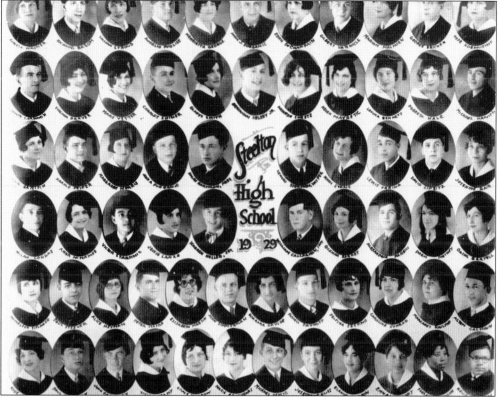

STEELTON HIGH SCHOOL CLASS OF 1929. Alumni of Steelton High School were especially loyal, as shown by the turnout for the 30th reunion of the class of 1929 in 1959. By the time of the reunion, enrollments had dropped as the steel industry went into decline. Steelton merged its school district with nearby Highspire by 1957 and built a consolidated school. The Steelton High School was in the Felton Building on Fourth and Walnut Streets, erected in 1900.

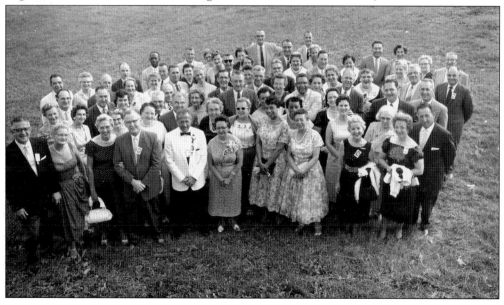

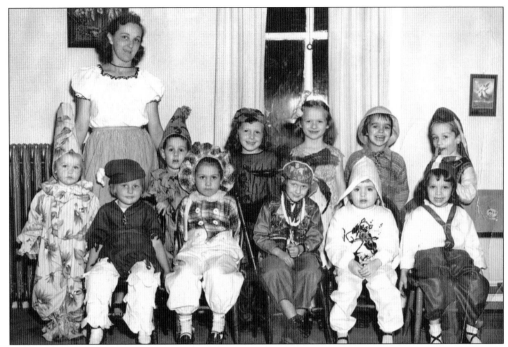

MISS STICKEL'S KINDERGARTEN, 1950s. Miss Stickel's private kindergarten class looks ready for Halloween. They were located in the 200 block of South Second Street. The owner of the photograph is seated in the middle of the front row. (Courtesy of Susan Silver Cohen.)

FELTON ELEMENTARY, C. 1957. Students in the sixth-grade class at Felton Elementary School in 1957 look either serious-minded (in front) or fun loving (in back). The school was named for the first president of the Pennsylvania Steel Company, Samuel M. Felton, for whom a street is also named. (Courtesy of Susan Silver Cohen.)

FAMILY AND TEAM DOCTOR, 1955. Dr. I. O. Silver, in 1955, administers a dose of gamma globulin to young Charles Kohl, who took it like a man, more or less. Dr. Silver was a leader in the vaccine campaign against polio in Steelton. The second photograph shows the legendary doctor leaving the field after performing his duties. He was the attending physician to Steelton's teams and always in attendance at the school's games and meets. Too small for football when he was a student at Steelton High School, he was the first drum major in the first marching band. The Roller Club honored him with a testimonial dinner in 1986, on the 50th anniversary of his service to school and community. The athletic director, John Beck, testified that "He had a loyalty to our athletes only someone born here could have." (Courtesy of Susan Silver Cohen.)

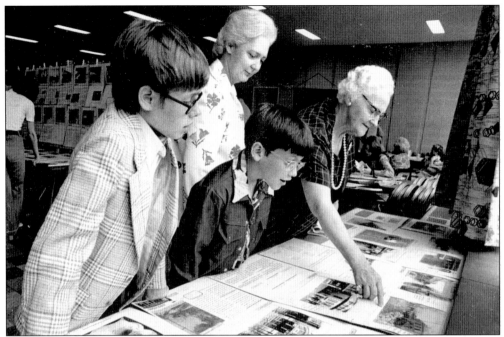

BICENTENNIAL HISTORY, 1976. Onlookers inspect John Yetter's photographs in 1976, on display in the cafeteria of Steel-High. The exhibit was sponsored by the Steelton Bicentennial Committee—referring not to the borough's 200th birthday but to America's. Such patriotic displays have been a hallmark of Steelton.

JOHN YETTER ENCOURAGES COMMUNITY HERITAGE AT STEELTON HIGHSPIRE HIGH SCHOOL, 1981. John Yetter on left, author of a book on Steelton history, encourages study of the community's heritage to students in John Beck's local history class at Steel-High in 1981. After the Steelton centennial celebration in 1980, Beck initiated the local history elective course. Beck, whose father and grandfather worked in the Bethlehem Steel Mill, was from Steelton. In this photograph, Yetter (1914–1994) explains to Greg Hindermyer and Pam Dissinger from Beck's class of 32 students the way the business district looked between 1870 and 1910.

Five

Sports and Leisure

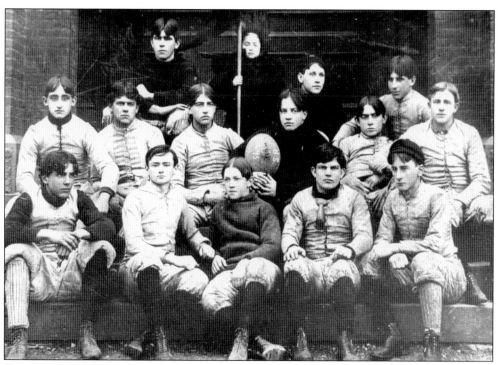

The First Steelton High School Football Team, 1895. Yetter's notes identify this photograph as the "SHS First Football Team 1895," although records show a Steelton High School team was playing in 1894. The 1895 team was not sponsored officially by the school because not all the boys attended Steelton High School. The football is emblazoned with "II. S. 95" The surnames of the players—Stacks, Dress, Morrow, Vaughn, and Markley, in the front row—suggest that the "new immigration" of southern and eastern Europeans had not yet affected Steelton football. The young lady in the back row, with the staff, is the mascot, Ethel Boudman. The lad in the first row, second from the right, wears around his neck what passed for protective face gear at that time—a nose guard.

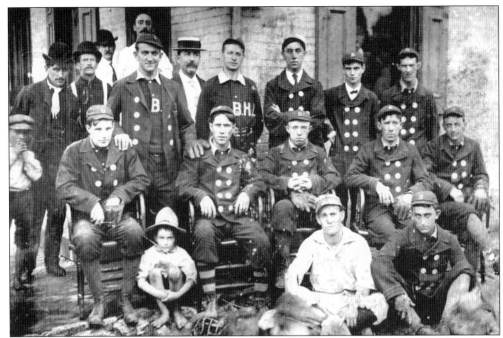

BESSEMER HOUSE BASEBALL TEAM, 1906. Bessemer House, a famous tavern in Steelton, was known in the region for hosting an annual festival with music and activities to raise funds for the team's equipment and field. The field was located on an island in the Susquehanna River that was reached by a steam-powered ferry from Steelton to New Cumberland on the west shore.

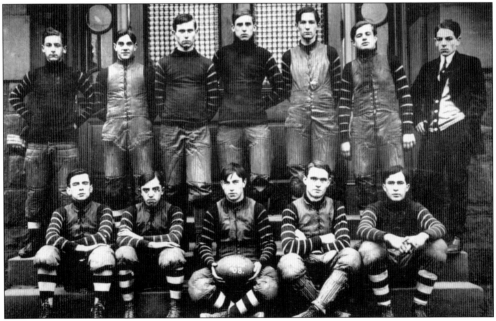

THE TEAM OF 1908. The boys in blue and white were solid that year, defeating Harrisburg Central twice in a row and the mighty Harrisburg Tech 11-0, winding up with a record of eight wins, three losses. Pat Reagan is out of uniform in the back row at the right end. Striped sleeves were the fashion in the past.

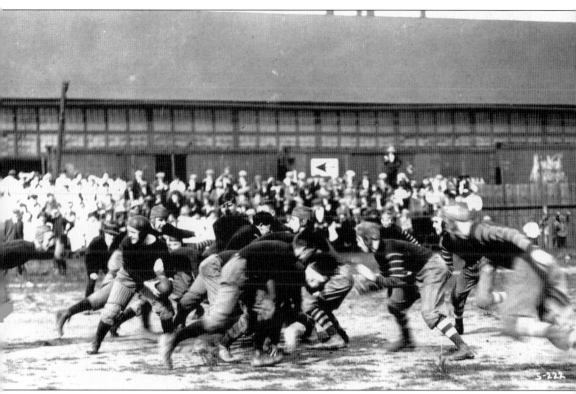

FOOTBALL GAME NEAR QUARRY, 1906–1907. Football was played on hardscrabble grounds by the steel plant in the early 20th century before the modern field at Cottage Hill was built. The old area near the town's quarry was known colloquially as "no man's land." In those years before common use of the forward pass, football games were typically smash-mouth battles pushing the ball forward with the run. Some especially gritty or foolish players pictured in this photograph eschewed helmets. In the two seasons of 1906 and 1907, Steelton High School lost only once, while collecting 19 victories, including triumphs over two college teams on their schedule. In 1907, they were scored on only twice for a total of 12 points, while compiling 127 points on offense.

LEGENDARY ATHLETE AND COACH PAT REAGAN, 1909. Pat Reagan played football, basketball, and baseball at Steelton High School, where he was photographed in his football uniform before graduating in 1910. He went on to captain Villanova's football team and played professional baseball for minor-league teams in Keene, New Hampshire, and Harrisburg before going off to war as a captain in the U.S. Calvary. After Steelton High School's uncharacteristic losing streak for several seasons, he was brought in as head coach in 1920. Despite his short tenure at the helm until 1924, he is often credited with establishing Steelton as a statewide football power with winning seasons every year. In 1924, his team went 8-1 and averaged 45 points a game. The lone loss was to Harrisburg Tech, 6-10, an equally legendary team once declared national champion. The defeat so affected Reagan that he resigned as coach. Yetter noted that he was a "Christian gentleman, *always*."

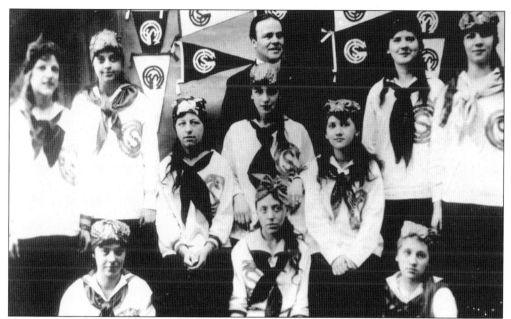

CENTRAL GRAMMAR SCHOOL GIRLS AND BOYS BASKETBALL TEAMS, C. 1917. Girls participated in scholastic sports in Steelton since early in the 20th century. Showing his approval in this picture is Bill Henry, Central Grammar School principal. Unlike their male counterparts, the girls' uniforms, featuring full-length dresses, covered most of their body. Many leagues adopted Senda Berenson's rules from the late 19th century to preserve womanly decorum. She divided the court into three sections and required the players to stay in their assigned areas. Snatching the ball, holding it for more than three seconds, and dribbling it more than three times were forbidden to create what its creators thought would be a more delicate game. The boys' team looks ready to play, but coach, as in the previous photograph, seems fixed on something to his left, or perhaps he wanted to avoid the camera flash.

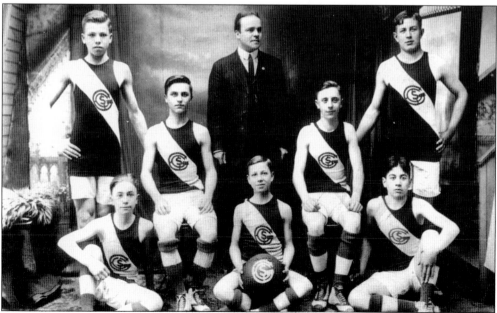

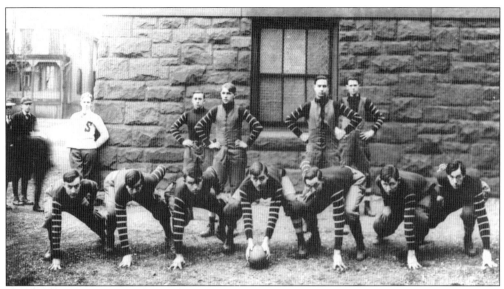

READY! HIKE! The backfield has hands on hips, and the line is in its three-point stance, ready to spring. They must be wearing their natty game uniforms. Unfortunately, the year and the players are not identified, but the photograph was probably taken around 1900.

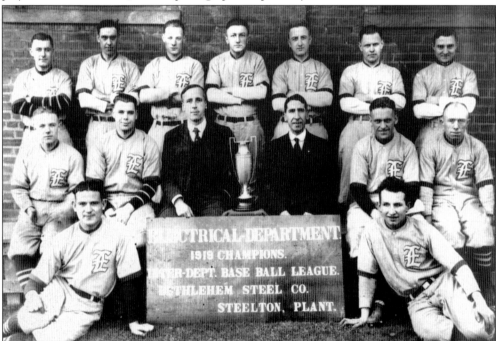

BETHLEHEM STEEL COMPANY INTERDEPARTMENTAL BASEBALL CHAMPIONS, 1919. Bragging rights for workers at the expanding steel mill was for the best departmental sports teams. Departments sponsored baseball teams in a highly competitive interdepartmental baseball league, mostly populated by the descendants of the assimilated descendants of 19th-century British and German immigrants. In 1919, the baseball crown went to the electrical department managed by G. J. Walz in the suit on the left of the trophy cup. Engineer J. C. Reed is to the right.

BETHLEHEM STEEL COMPANY BASEBALL TEAM, 1920. In addition to having an interdepartmental league, the Bethlehem Steel Company also sponsored a team that played other industrial squads dotting the central Pennsylvania landscape. The man in a suit was the scorekeeper Clyde Snyder, and the youngster on the ground was the batboy Ernie Wigfield. The manager is seated fourth from the left.

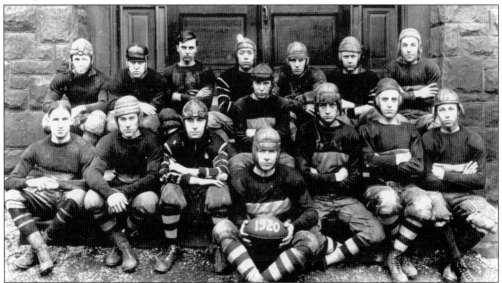

STEELTON HIGH SCHOOL FOOTBALL SECOND TEAM, 1920. Young men who were not starters could still be proud of making the second team, shown here in 1920, wearing leather helmets and striped stockings. John Yetter believed the 1920s were the hallmark years of Steelton football. That was a time when not only the borough and the high school but also Bethlehem Steel Company took football seriously, going so far as to hire employees who had credentials to be good coaches. The year 1920 was Pat Reagan's first year coaching, when he turned the team around.

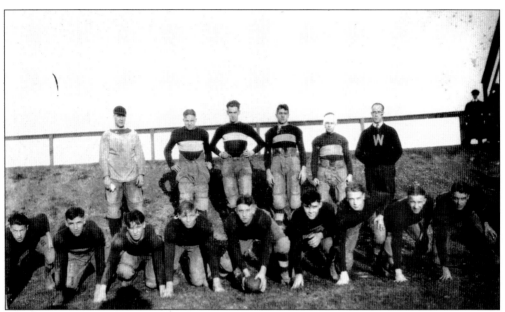

BEN BOYNTON WITH STEELTON HIGH SCHOOL FOOTBALL TEAM, 1922. Pictured with the 1922 Steelton High School football team is assistant coach Ben Lee Boynton (1898–1963) in the top row, far right, with a W on his sweater. The letter represents his experience as quarterback at Williams College from 1917 to 1920 where he was named to Walter Camp's All-America team. After graduating, Boynton went to work at Bethlehem Steel in Steelton and helped head coach Pat Reagan mold Steelton High School into a statewide power. He played professional football with five different teams, including the pre-NFL Buffalo Bisons and Frankford Yellow Jackets. Boynton was elected to the College Football Hall of Fame in 1962.

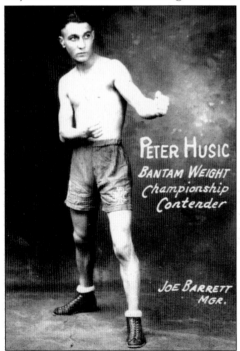

PETER HUSIC, BANTAMWEIGHT CHAMPIONSHIP CONTENDER, 1920S. Born in Steelton in 1903, Peter (Pete) Husic earned national notice for winning 65 professional fights by knockout in the bantamweight class between 1921 and 1927. In 1922, he fought for the bantamweight championship of the world against Joe Lynch, which resulted in a draw. He retired to Harrisburg and died in 1953.

MARLIN E. ESHELMAN, 1920S.
Middleweight Marlin "Jack" Eshelman was a popular fighter during the 1920s when Harrisburg was known as a hotbed of boxing action. He was known as a vicious puncher resulting in knockouts, earning him the moniker of "Pennsylvania's KO Kid." This photograph lists his manager as Joe Kennedy, for whom he fought in Philadelphia until he quit the ring in 1925. Born in 1902 in Steelton, he returned to Steelton to live with his sister and work for the steel plant. He died in 1964.

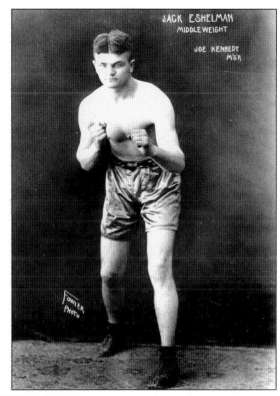

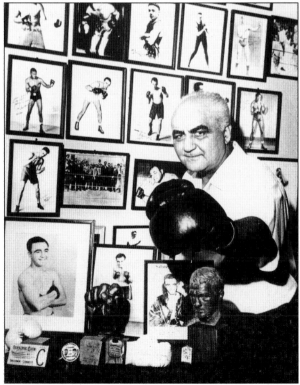

DEMO ATANASOFF'S HOME MUSEUM OF BOXING, 1970S.
Demo Atanasoff of Steelton won a Golden Gloves championship at 126 pounds during the 1930s and boxed professionally afterward as "Young Demoe." His publicity photograph from 1939 appears in the lower left corner. He collected memorabilia from the sport and opened his home on Pine Street to visitors who wanted to see the nationally known collection. In 1977, he was inducted into the Pennsylvania Sports Hall of Fame.

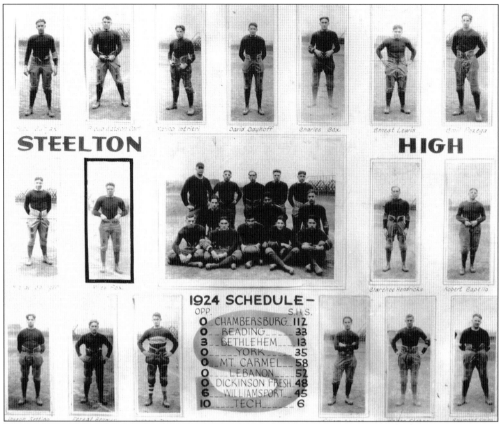

STEELTON **HIGH**

1924 SCHEDULE –	
OPP.	S.H.S.
0 CHAMBERSBURG	112
0 READING	33
3 BETHLEHEM	13
0 YORK	35
0 MT. CARMEL	58
0 LEBANON	52
0 DICKINSON FRESH	48
6 WILLIAMSPORT	45
10 TECH	6

STEELTON HIGH SCHOOL "IRONMEN," 1924. This composite photograph of Steelton High School's fearsome football team also displays its 1924 record. The team was considered overpowering, until it met the equally fearsome Harrisburg Tech team in the last game of the season. Up to then, Steelton had outscored its opponents 396 to 9, but was edged by Harrisburg Tech 10-6.

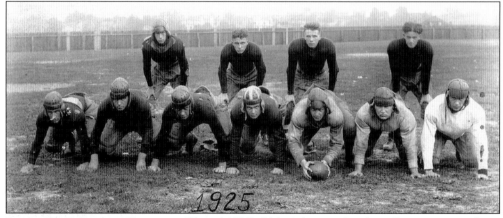

STATE CHAMPIONSHIP FOOTBALL TEAM, 1925. Although considered small in stature, with no players weighing more than 180 pounds, the 1925 team was a powerhouse team that was named state champion. Under head coach J. Paul Rupp, they outscored opponents 375 to 29, including a 91-3 thumping of Williamsport.

ANOTHER STATE CHAMPIONSHIP FOOTBALL TEAM, 1926. This was the first undefeated, untied team in school history. The defense on this championship team was awesome. Of its 12 opponents, 8 did not score a point. Overall, captained by Miles Fox (second from left, middle row) and Ernie Lewis (far left, middle row), Steelton High School rang up 310 points to the other side's 43. The closest game was with the Pennsylvania Railroad Juniors, who were defeated 6-0. The game with perennial opponent Williamsport was also close, 19-14. In the final game of the season, Steelton High School defeated Johnstown, western champion, 39-0. Pennsylvania high school football teams, incidentally, lead the nation in number of games played. Williamsport ranks first, Pottsville is second, and Steelton is third (1,121 games played, as of 2006), only six games below first.

LEGENDARY ATHLETE MILES FOX, 1926. A multitalented athlete, Miles Fox established football records in 1926 for most points in a season (194) and most touchdowns (32). His senior year, he led Steelton as a first-team all-state player to state championships in both football and basketball. He also starred on the track team, placing in the state finals in discus and shot put. He went on to the United States Naval Academy where he mysteriously died at the tender age of 19 after football practice in September 1928. A Harrisburg newspaper reported that "several thousand awaited the cortege at the cemetery, thronging for a last view. The funeral procession was the longest ever seen here, the mourners filling more than eighty automobiles. The streets were lined with people who stood silently by as the cortege passed."

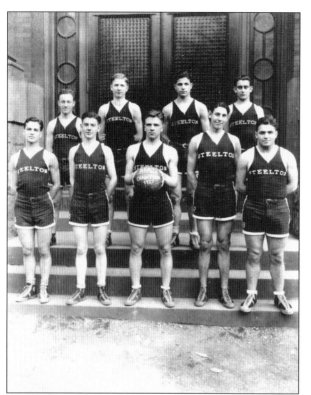

STEELTON HIGH SCHOOL, STATE BASKETBALL CHAMPIONS, 1927. During the 1926–1927 season, Steelton High School swept all the titles in basketball: league, district, Eastern regional, and state championships. The team was led by forward Miles Fox (holding ball) and center Cal Heller (first row, second from right), who both went on to be named first-team all-state. The team went 23-1 and beat Sharon High School in the state championship. The team avenged its only loss to Lebanon, a close five-point margin early in the season, by beating them in a rematch by 40 points, 56-16, on the way to an 18-game winning streak.

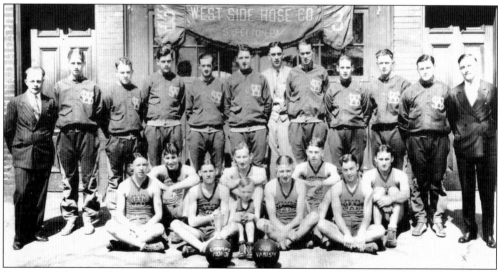

STEELTON FIREMEN'S LEAGUE BASKETBALL CHAMPIONS, 1931. Within Steelton, the Firemen's League produced fierce neighborhood rivalries for many athletes after their high school glory days were over. The different hose companies fielded "sub-varsity" as well as "varsity" teams following the model of scholastic teams. In 1931, the West Side Hose Company boasted the league championship and both squads posed together. The varsity is seated and the sub-varsity is standing. The team featured former all-state center Cal Heller (second row, far left), who was a member of the 1927 state championship high school team. The young mascot with the varsity is Lee Murphy.

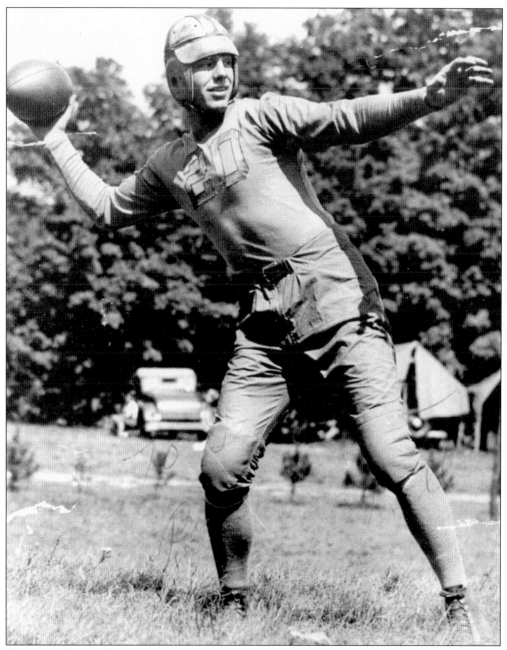

WARREN "FATS" HELLER, ALL-AMERICAN RUNNING BACK, 1932. Heller was an outstanding running back on powerful Steelton High School teams from 1926 to 1928 that accumulated a 27-3-2 record, including the undefeated state-championship team of 1926 that went 12-0. In his final season, he led the district in scoring with 149 points, including a memorable five-touchdown game against Columbia. In the college ranks, he earned All-America honors in 1932 at the University of Pittsburgh and held the school's rushing record until the 1970s. He played football in the NFL for the old Pittsburgh Pirates for three seasons and compiled 2,000 all-purpose yards.

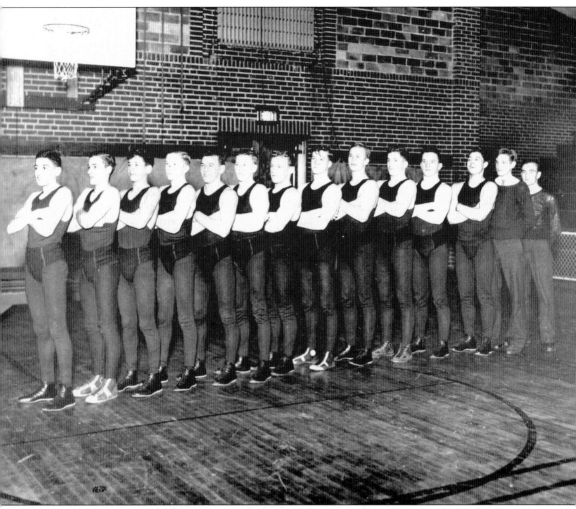

STEELTON HIGH SCHOOL'S FIRST WRESTLING TEAM, 1936–1937. Steelton added its first wrestling team during the 1936–1937 season and enjoyed success in the sport, especially during the 1977–1978 and 1978–1979 seasons when it won the Section II AA and Mid-State League championships, respectively. From the team pictured here, Miles Belic, second from the left, went on to become district champion in the 135-pound weight class the following year. The team won its first district championship in 1940–1941.

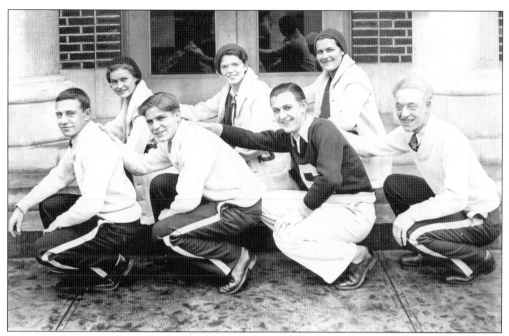

STEELTON HIGH SCHOOL CHEERLEADERS, 1932. Despite the start of the Great Depression, the spirited cheerleaders pictured here in 1932 had a lot to cheer about. That year, the Steelton High School men's basketball team went 20-2 and captured Central Pennsylvania College and District 3 titles.

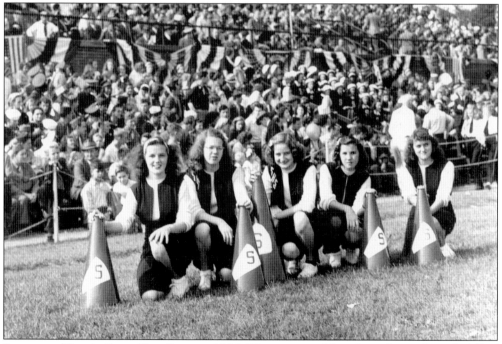

STEELTON HIGH'S FIRST PEP SQUAD, 1946. The pep squad kneels in front of stands full of fans in 1946. Girls have replaced boys, and ethnicity is in place. From left to right are Jeanette Kosevic, Helen Ann Furlan, Frances Gustin (leader), Mildred Yovanovich, and Marie Coccia.

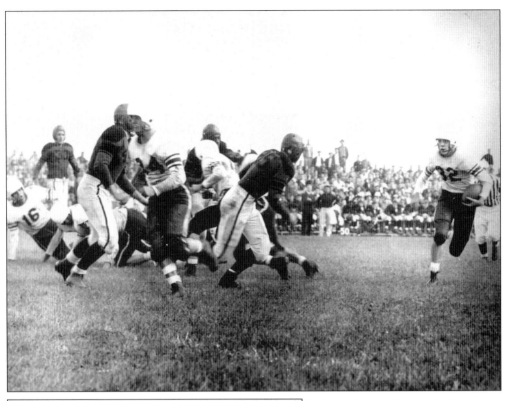

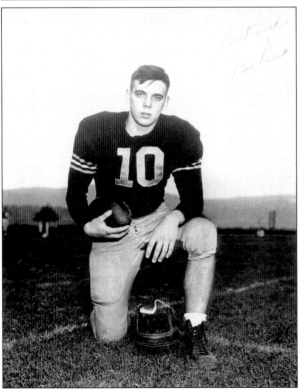

GIL REICH IN ACTION. Among Steelton's legendary athletes was Gil Reich, who quarterbacked the Steelton High School team in the late 1940s. In 1952, he was a two-team standout at the University of Kansas, where he made the All-America team as a defensive back and showed versatility as a quarterback, tailback, and punt returner. He also played as a starting guard on the Jayhawk basketball team in 1953 that went to the finals of the NCAA tournament.

RICHARD (DICK) REICH, ALL-AMERICAN FULLBACK, 1950. Dick was the younger of the athletic Reich brothers (see photograph of Gil) who played together on the undefeated, state-champion Steelton team of 1948 that shut out 6 of its 10 opponents and averaged 31 points a game. In 1951, the Heisman Club placed Dick on its high school All-America team. He was also a star basketball player and went to West Point as a two-sport varsity player, before transferring to Kansas.

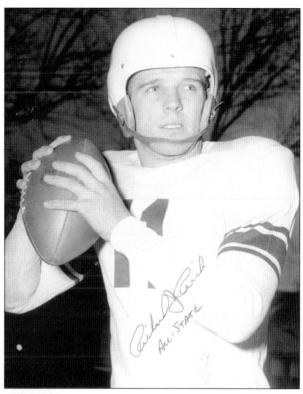

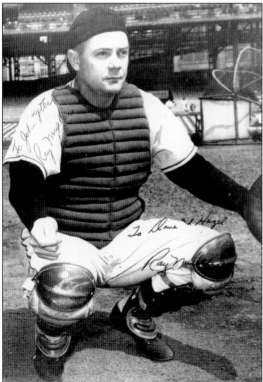

MAJOR-LEAGUE PLAYER RAY MUELLER. Although hailing originally from Pittsburg, Kansas, professional baseball player Ray Mueller called Steelton home from 1938 until his death in 1994. He came to the area to play with the minor-league Harrisburg Senators in 1932 at the age of 20. He moved up to the professionals as a catcher in 1935 with the Boston Braves before being traded to the Pittsburgh Pirates in 1938. His career was interrupted by service in World War II; when he got out of the military in 1943, he joined the Cincinnati Reds where he stayed until 1949. In 1944, he was selected to the all-star team and was a contender for the league's Most Valuable Player award. He had a reputation as a durable, reliable player. In 14 seasons, he compiled a .252 batting average and in 1944 placed third in the league for most games played. He finished his career where he started, with Boston in 1951. After his playing days were over, he worked as a scout for the Cleveland Indians and Philadelphia Phillies.

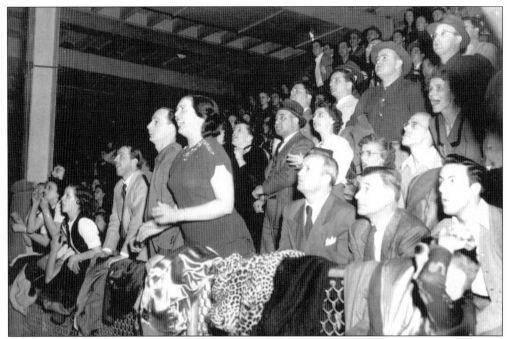

STEELTON HIGH SCHOOL BASKETBALL FANS IN OLD GYMNASIUM, 1950S. Steelton basketball fans have been known for their loyalty and exuberance since 1902, when the first high school game was played. In 100 years, Steelton teams have won 59 championships at the local, regional, and state levels, including five state championships. In one notable stretch from 1997 to 2001, Roller teams won four consecutive district championships and two state titles. Pictured here is a scene from the gymnasium before the Steelton-Highspire school building was dedicated in 1959. Separating the fervid crowd from the court is a chain-link fence.

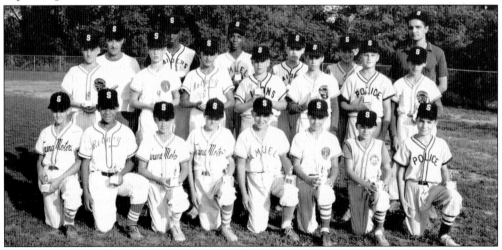

STEELTON LITTLE LEAGUE ALL-STARS, 1962. Steelton has had a range of athletic youth programs, including Little League baseball. Baseball had been embraced by the second and third generation of immigrants from southern and eastern Europe, and African Americans were integrated into the teams. Pictured here, for example, in the top row are coaches Ike Belic and Fred Sosnowski at the ends with Chuck Palmer, E. Erby, Mike Spanitz, and Joe Vajda in between.

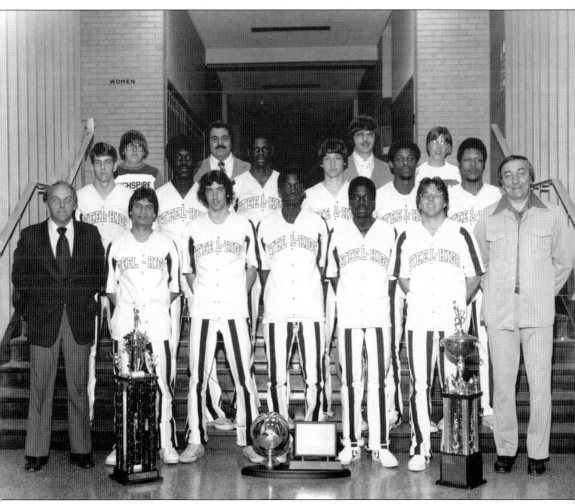

STEELTON HIGHSPIRE HIGH SCHOOL BASKETBALL TEAM, 1977. The Rollers went undefeated in their league and compiled an overall record of 29-3 under head coach Marty Benkovic (first row, far right). In the tight playoff game against Nanticoke won by Steel-High 87-83, star player Greg Manning (second row, third from right) scored a state-playoff record 57 points. He also went into the record books for the high school with a single season total of 859 points. He was named first team all-state and went on to play Division I basketball at the University of Maryland. During a stretch from 1974 to 1978, Roller basketball teams coached by Benkovic amassed 96 wins against only 20 losses. Benkovic stepped down as coach after the 1980–1981 season before returning briefly in 1987–1988. In his 19 seasons, he amassed more wins than any other basketball coach (345), as well as a higher winning percentage (72 percent). During that time, his teams won three Eastern State and five district championships. Steel-High's gymnasium was later named in his honor.

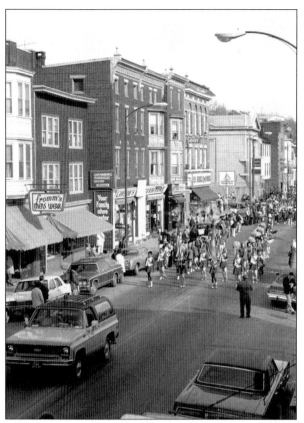

PARADE FOR EASTERN BASKETBALL CHAMPIONS, 1977. Steelton residents honored the Eastern State champion basketball team from Steel-High with a parade down Front Street on March 24, 1977. The portion of the parade captured in the photograph is Mulberry and Locust Streets and shows a number of family-owned businesses, including Fromm's Men's Wear, Lawson's Furniture, and Cherry's Shoes.

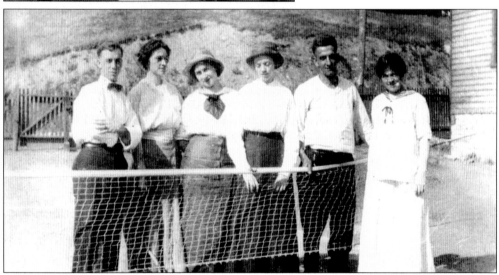

ST. JAMES TENNIS CLUB, 1911. Only 30 years after the United States Lawn Tennis Association first standardized rules and organized competitions, enthusiasts of the new sport formed a tennis club using a Catholic church school yard on North Second Street to play. During the 1920s the club built two courts better suited to the sport in the 600 block of North Third Street. Pictured here from left to right are some youthful original members, Andy Hetzel, Helen Shannon, Gert Shannon, Margaret Dailey, Jake Hetzel, and Nora Gaffney.

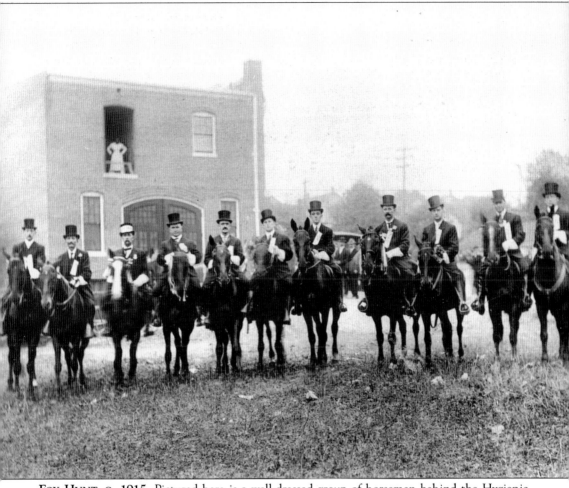

FOX HUNT, C. 1915. Pictured here is a well-dressed group of horsemen behind the Hygienic Hose Company fire hall about to go out on a foxhunt, or a fox chase, as it is commonly known in the United States. The American term refers to the tradition that the quarry is not killed but pursued; it also demonstrates horsemanship. Introduced by the English in the Middle-Atlantic region during the 17th century, the hunt became associated with recreation of the elite class.

LAWN PLAY GROUNDS. Children—boys with boys, girls with girls—crowd the lovely Lawn Play Grounds at 123 North Front Street on a bright summer day. A bandstand on the playground was used for concerts. The steel gate at the right was once the main entrance to the home of the steel plant's general manager. John Yetter considered the "Lawn" to be the most representative of the borough's playgrounds, as it was used by most residents.

Fish Caught in the Susquehanna River, 1909. Fishing in the Susquehanna River provided both food and sport for many Steelton residents. Among the species hooked in the river were carp, suckers, mullets, and eels. Pictured here are young Joseph Salinger and Mae Nelson with a large carp. Newspapers of the era reported noteworthy carp measuring four feet long and weighing over 30 pounds.

GIRLS AT BAILEY'S ISLAND, 1921. Girls from the Harrisburg YMCA pose at Bailey's Island in 1921. Lloyd and Martha Bailey purchased the island from Jim Zimmerman in 1919 and built their cottage Marllo there with lumber from the demolished company store building. Other locals built cottages there too. In his book, *Steelton, Pennsylvania: Stop–Look–Listen*, John Yetter wrote about the river's islands, "they were a vital part of the Steelton people's summer life."

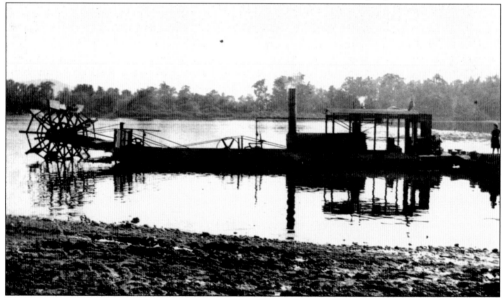

STEAMBOATING ON THE SUSQUEHANNA. The Susquehanna River was good for fun making as well as steelmaking. This steamboat was used for special trips from Steelton's "beach" to islands in the river. It was owned by the Downeys and was leased on the weekends by "Deacon" Shrauder for island junkets. Yetter writes in his notes, "One of the events I remember best from the early Twenties was visiting the 'farm island' next to Bailey's [island] on a day the Baldwin Hose Co. [volunteer firemen] was having a picnic there. Wowee!" Church groups also used the steamboat for transit to baptisms.

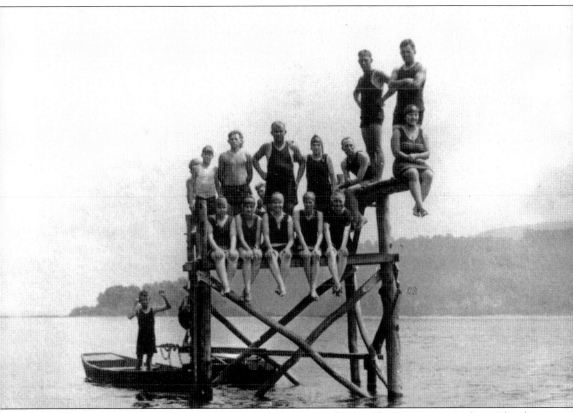

PLATFORM DIVING. Young and old pose on Steelton's diving platforms near Bailey's Island. Swimming in the river was commonplace recreation throughout the Susquehanna valley during warm weather, and walking on the river ice was attempted in the winter. The amateur architecture of the platforms ranged from practical to eye-popping.

AL GORNIK'S FIELD HOUSE, 1970S. Al Gornik's Field House at the east end of Steelton was a recreational and dining institution in sight of the steel mill. It was a prime meeting spot for sports fans after games and a banquet location for Mid-Penn High School Conference officials. The walls of the field house were always decorated with sports memorabilia of the town and owner Al Gornik's beloved Notre Dame football teams. In keeping with the eastern European traditions of the town, Gornik featured polka dancing on Saturday nights, advertised on the sign out front. In 1998, after closing hours, a fire destroyed the field house, but it was rebuilt as KoKoMo's Sports Grill and Bar.

DRESSED UP FOR THE HALLOWEEN PARADE. Halloween rose in popularity as an American holiday celebration during the mid-20th century as it combined elements of different ethnic traditions, including trick and treating, making of jack-o'-lanterns, bobbing for apples, and costuming. A tradition in many Pennsylvania communities was the Halloween parade, allowing children and adults alike opportunities to dress up and even cross-dress. Pictured here are Helen (Yetter) Murphy and her brother Maurice Yetter after Steelton's annual Halloween parade, probably during the 1950s.

Six

FLOODS, WARS, AND CRISES

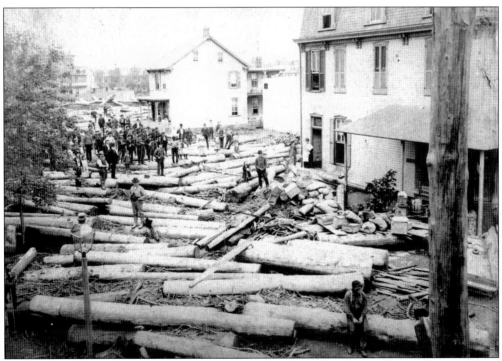

LOGS IN STREET AFTER THE 1889 FLOOD. In early June 1889, the waters of the Susquehanna River crested at 10 feet above flood stage. In addition to the torrent of water, residents had logs floated downriver from Williamsport to contend with. The heyday of Pennsylvania's lumbering industry extended from the late 19th century to the early 20th century, and the river was used to transport logs as rafts.

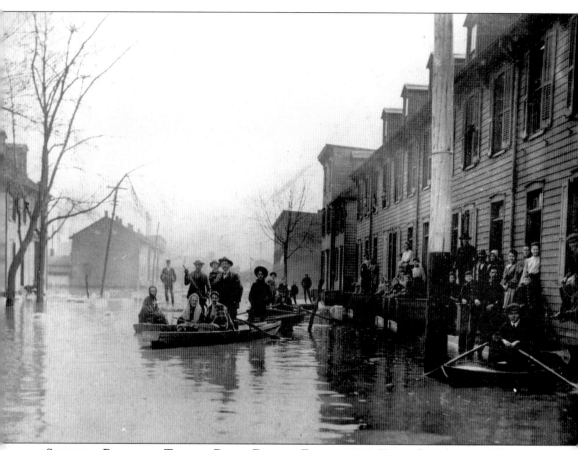

STEELTON RESIDENTS TAKE TO BOATS DURING FLOOD, 1902. Trapped residents on Christian Street in Steelton's old west side are rescued by boat after the flood in March 1902. Smokestacks of the steel plant rise above the houses in the background.

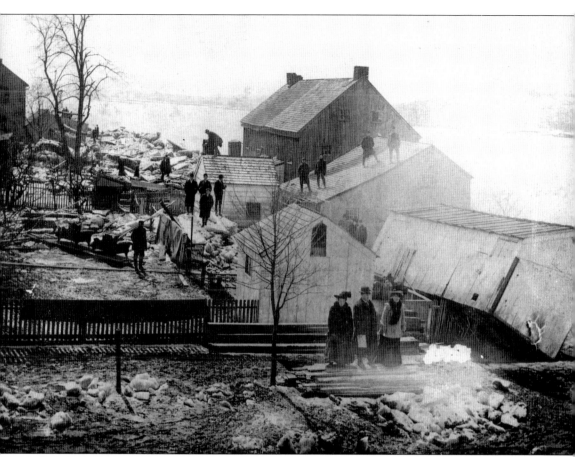

CLEANING UP AFTER THE FLOOD, 1902. The waters in the flood of early March 1902 did not reach as high as other times when the Susquehanna River spilled over its banks into Steelton, but it caused significant damage because chunks of ice from the frozen river crashed into buildings along shore and in some cases upended them, especially on the town's old west side. The river crested at close to 24 feet, seven feet above flood stage and three less feet than the flood of June 1889. But fresh on the heels of the river cresting over 21 feet in December 1901, and followed by damage from icy waters over 23 feet in March 1904, town leaders called for some action to stem the path of future floodwaters. The Pennsylvania Railroad responded by raising its roadbed and tracks along the river by several feet, creating a barrier between the river and town. Although the river rose above flood stage several times from 1910 to 1925, the town did not suffer significantly until 1936, when the river rose over 30 feet and washed over the railway barrier into the business district. It was the 11th time since the incorporation of Steelton that waters rose above flood stage in March. The pattern stirred longtime residents to half-jokingly warn newcomers to "beware the ides of March."

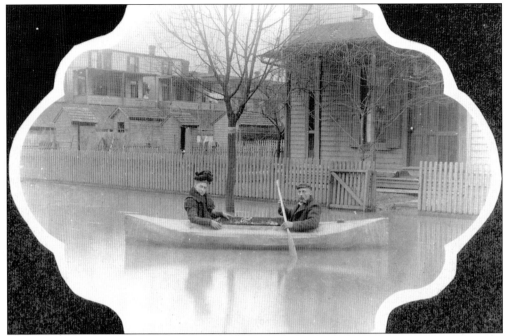

THE FLOOD OF 1904. Mr. and Mrs. Ellywn Stoner placidly paddle through the floodwaters of 1904, dressed for another occasion, it would seem. At that time they resided at 179 Myers Street and Ellywn worked at the Pennsylvania Railroad depot. Soon afterward they moved to higher ground, at 313 Walnut Street, but still in Steelton.

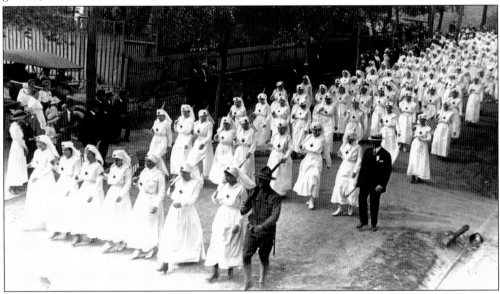

GREAT PARADE FOR THE GREAT WAR. Red Cross women march on Franklin Street between Second and Front Streets in the greatest parade in Steelton's history—12,000 assembled on May 19, 1917. The point of the parade was "Preparedness," for the United States had just entered World War I. As E. L. Doctorow writes in *Ragtime*, in those days "the population customarily gathered in great numbers either out of doors for parades, public concerts, fish fries, political picnics, social outings, or indoors in meeting halls, vaudeville theatres, operas, ballrooms."

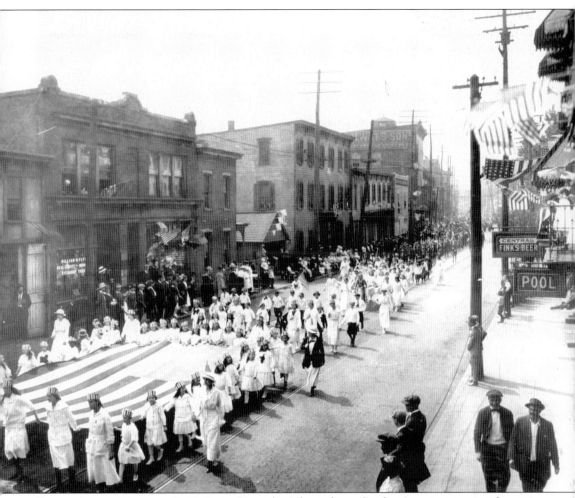

PREPAREDNESS PARADE, 1917. Front Street has always been Steelton's main street, and many parades followed its route. The occasion for this patriotic display is the entrance of the United States into World War I in 1917. Called the Preparedness Parade, it signaled readiness and national will for fighting abroad. One can see signs on the right for the pool hall and beer sales. Two years later, the National Prohibition Act made the sale of liquor at such establishments illegal.

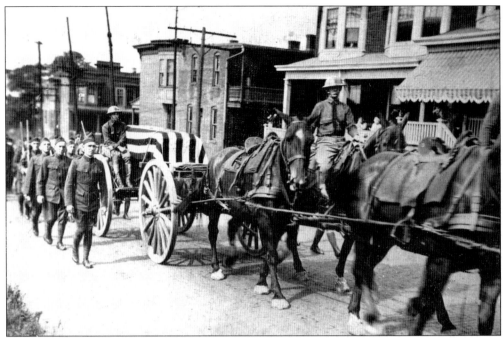

FUNERAL PROCESSION OF SGT. LAWRENCE L. CHAMBERS, 1918. A hometown hero, Sgt. Lawrence L. Chambers was killed in the Argonne Forest and given funerary honors with a military caisson and a procession with military band playing "Onward Christian Soldiers" to Mount Calvary Cemetery. The Veterans of Foreign Wars Lawrence L. Chambers Post 710 on Front Street in Steelton was named in his honor.

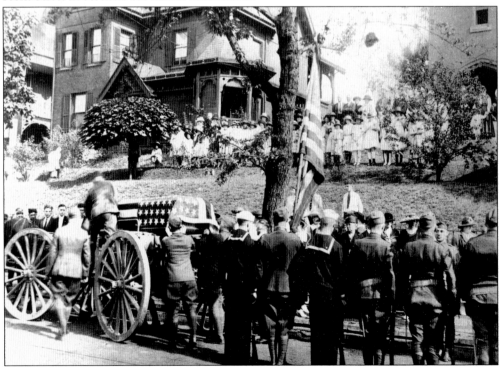

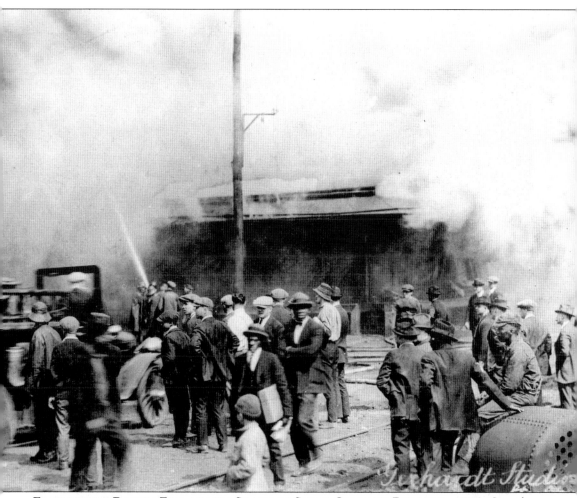

Firefighters Battle Fire at the Steelton Store Company Building, 1924. Crowds gathered on April 24, 1924, to view the battle of firefighters against a huge blaze at the building formerly occupied by the Steelton Store Company. The company store, as it was known, had given way to a grocery and provisions business called the Black and White Store located elsewhere that did not operate as the company store did on customers' payroll deductions. The old building was being used as an automobile storage area when the first alarm sounded in the early afternoon. For four hours, fire companies from Harrisburg, Highspire, and Enhaut, besides the Steelton crews, worked to contain the fires. When the smoke cleared, the fire chief declared a toll of $125,000 damage in the disastrous fire.

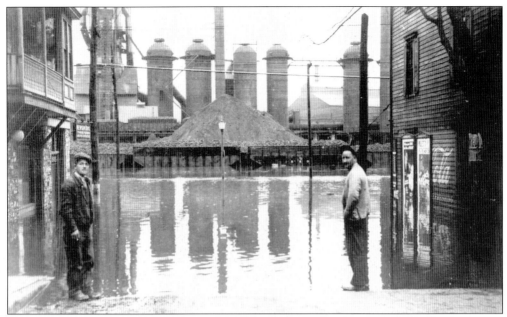

WATCHING THE 1936 FLOOD. Two men stand by the river that has moved into the downtown area. The 1936 flood was the second worst in the state's history, but most of the neighborhoods and businesses made it through and recovered.

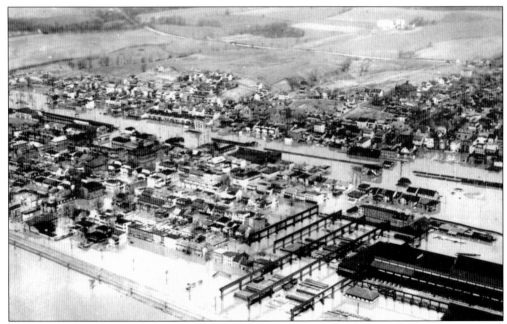

AERIAL VIEW OF FLOODING ON WEST SIDE OF STEELTON, 1936. This photograph shows the extent of flooding in 1936 when the Susquehanna River crested at more than 13 feet above flood stage. The roadbed of the Pennsylvania Railroad, which had been raised after the 1904 flood to provide a barrier to the river, did not impede the flow of water into the old west side and the business district.

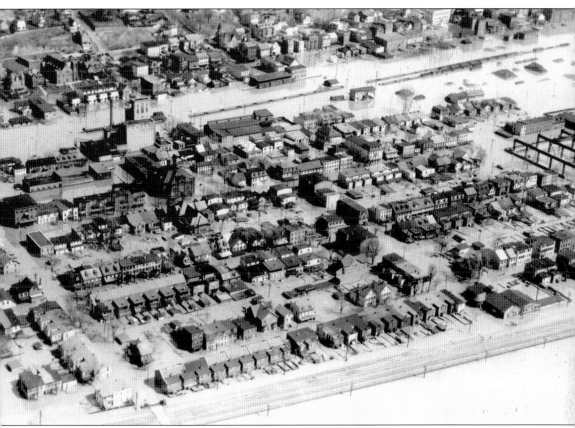

WEST SIDE, STILL WET, 1936. The lower west side is still inundated on March 20, 1936, the morning after the flood. The neighborhood survived this one but not the 1972 flood, which led to the clearing of most structures. Front Street is flooded in the background, while the homes on the hills were spared.

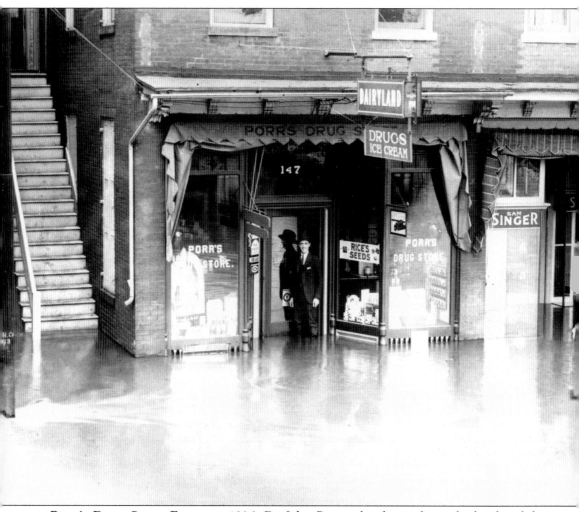

PORR'S DRUG STORE FLOODED, 1936. Dr. John Porr in hip boots shows the height of the floodwaters in March 1936. The Susquehanna River crested at 30.33 feet, 13 feet above flood stage. The waters stretched beyond the west side of town in the flood plain and reached every section of the town. Porr's store was on Front Street.

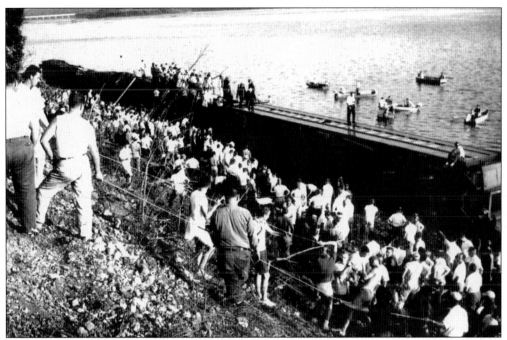

BASEBALL TRAIN WRECK, 1962. On the hot summer day of July 28, 1962, an insecure track in Steelton caused the derailment of an eastbound train carrying passengers to watch the home team Philadelphia Phillies take on the Pittsburgh Pirates. Newspaper reporters at the time called the "baseball special train wreck" the worst rail disaster in Pennsylvania history. A few minutes after the train left Harrisburg, the last three cars of the train broke loose and knocked down three poles supporting high-voltage power lines. The cars plummeted down a 40-foot embankment into the Susquehanna River, and bodies scattered. Of the 140 passengers and crew aboard, 19 died and over 100 were injured.

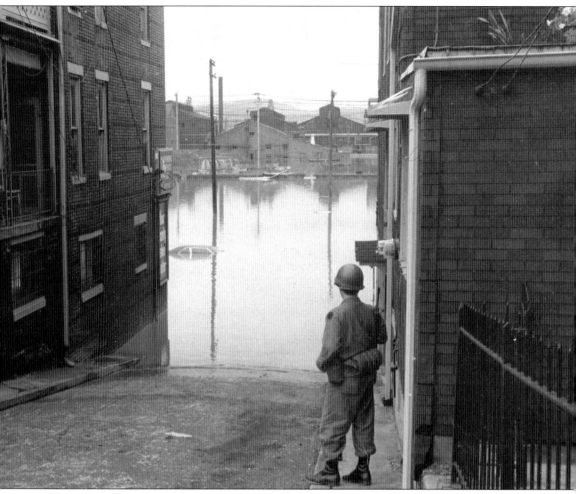

NATIONAL GUARD IN STEELTON AFTER THE 1972 FLOOD. In late June 1972, looking down Mulberry Street to Front Street, a Pennsylvania National Guardsman ponders the overflowing Susquehanna River and the inundated Bethlehem Steel mills. Hurricane Agnes had dumped up to 13 inches of rain on the Susquehanna valley, raising the river's height to 32.8 feet at Harrisburg, where the normal level was 5 feet. On Steelton's west side, 310 houses were flooded, never to be restored. Damage costs in Steelton were over $5 million.

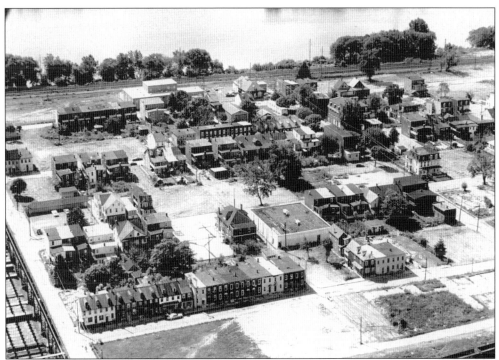

LOWER END OF OLD WEST SIDE. This is an aerial view of the mostly abandoned buildings of the lower end of the old west side of Steelton. The area, once noted for the close-knit neighborhood ties among its residents, was devastated by the flood of 1972 triggered by Hurricane Agnes. Afterward, the Dauphin County Redevelopment Authority launched an urban renewal project that removed 455 structures from the area next to the Bethlehem Steel plant. The second photograph shows a closer view of the mess and the last remaining structures on Myers Street.

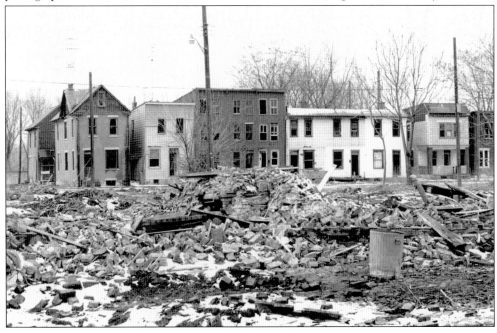

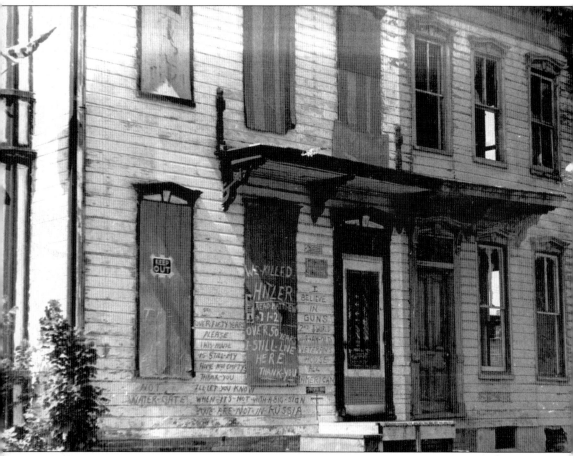

PROTEST OF WEST SIDE REMOVAL, 1976. Pictured is the graffiti by one of the last holdouts on Main Street. The resident was scheduled for relocation from the old west side by the Dauphin County Redevelopment Authority's urban renewal project after the flood of 1972. Reflecting cold war rhetoric, the owner has written, "Over fifty years, please, this house is still my home, not empty, thank you. I'll let you know when it's not with a big sign. We are not in Russia." The protest was unsuccessful in stopping the bulldozers.

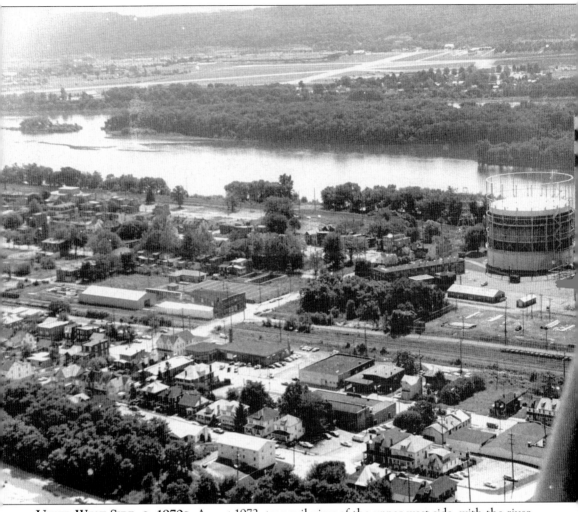

Upper West Side, c. 1970s. A post-1972, tranquil view of the upper west side, with the river in the distance, shows many properties gone and some remaining. Steelton could always look impressive from a distance or from an aerial view. The mill made other places look impressive too, such as San Francisco, by providing steel for the Golden Gate Bridge.

NEW STEELTON. An improvement underway signals that even more positive changes are in store, according to the Steelton Economic Development Corporation. Front Street will have more attractive intersections, and a downtown office park is planned for both sides of the street. Public-private partnerships have worked in other places to bring cities up to date and promote economic growth. But whatever the planning and the partnership are, the question remains: What kind of community will the future bring? (Photograph by Simon J. Bronner.)

BIBLIOGRAPHY

Barton, Michael. *Life by the Moving Road: An Illustrated History of Greater Harrisburg.* 2nd ed. Sun Valley, CA: American Historical Press, 1998.

Beers, Paul B. *Profiles from the Susquehanna Valley.* Harrisburg, PA: Stackpole Books, 1973.

Bodnar, John E. "Peter C. Blackwell and the Negro Community of Steelton, 1880–1920." *Pennsylvania Magazine of History and Biography* 97 (1973): 199–209.

———. "Immigration and Modernization: The Case of Slavic Peasants in Industrial America." *Journal of Social History* (Autumn 1976): 44–71.

———. "The Impact of the 'New Immigration' on the Black Worker: Steelton, Pennsylvania, 1880–1920." *Labor History* 17 (1976): 214–229.

———. *Steelton: Immigration and Industrialization, 1870–1940.* Pittsburgh, PA: University of Pittsburgh Press, 1990. First published 1977 as *Immigration and Industrialization: Ethnicity in an American Mill Town, 1870–1940.*

Eggert, Gerald G. *Harrisburg Industrializes: The Coming of Factories to an American Community.* University Park, PA: Pennsylvania State University Press, 1993.

Eyster, Warren. *No Country for Old Men.* New York: Random House, 1955.

Hoffman, David F. "The Meaning and Function of the Kolo Club 'Marian' in the Steelton, Pennsylvania Croatian Community." *Keystone Folklore Quarterly* 16 (1971): 115–131.

Jutronic, Dunja. "Language Maintenance and Language Shift of the Serbo-Croatian Language in Steelton, Pennsylvania." *General Linguistics* (Summer-Fall 1976): 166–186.

Kallman, Diane. "Steel on the Susquehanna." *Pennsylvania Heritage* 16 (1990): 32–37.

McLellan, Marjorie L. "Case Studies in Oral History and Community Learning." *Oral History Review* 25, no. ½ (Summer 1998): 81–112.

O'Brien, Sharon. "A Short Reflection on Teaching Memoir and Oral History." *Oral History Review* 25, no. ½ (Summer 1998): 113–117.

Steelton Core Feasibility Study Team. *Borough of Steelton Community Development Core Feasibility Study.* Kairos Design Group and Powers and Associates, 2005–2006.

U.S. Immigration Commission. *Reports of the United States Immigration Commission: Immigrants in Industries, Pt. 2: Iron and Steel.* 2 vols., 61st Cong., 2nd sess., 1911. S. Doc. 633, serial 5669, 581–732.

Yetter, John B., with Harold L. Kerns. *Steelton, Pennsylvania: Stop–Look–Listen: Home Town of the First Plant in the United States Built to Make Steel.* 2nd ed. Harrisburg, PA: Triangle Press, 1980.

Across America, People are Discovering Something Wonderful. Their Heritage.

Arcadia Publishing is the leading local history publisher in the United States. With more than 3,000 titles in print and hundreds of new titles released every year, Arcadia has extensive specialized experience chronicling the history of communities and celebrating America's hidden stories, bringing to life the people, places, and events from the past. To discover the history of other communities across the nation, please visit:

www.arcadiapublishing.com

Customized search tools allow you to find regional history books about the town where you grew up, the cities where your friends and family live, the town where your parents met, or even that retirement spot you've been dreaming about.